THE SECOND WORLD WAR IN

1940

JOHN CHRISTOPHER & CAMPBELL McCUTCHEON

AMBERLEY

First published 2014

Amberley Publishing
The Hill, Stroud
Gloucestershire, GL5 4EP

www.amberley-books.com

British Library Cataloguing in Publication Data.
A catalogue record for this book is available from the British Library.

ISBN 978 1 4456 2207 1 (print)
ISBN 978 1 4456 2223 1 (ebook)

Typeset in 11pt on 15pt Sabon.
Typesetting and Origination by Amberley Publishing.
Printed in the UK.

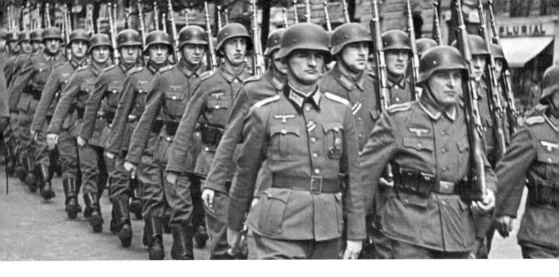

Contents

ISSUED BY THE MINISTRY OF HOME SECURITY

INTRODUCTION

The winter of 1939/40 was a harsh one in Western Europe. With the ground frozen over and conditions underfoot difficult, the Allies and Germans waited behind their frontiers, building defences and preparing for action. The period known as the 'Phoney War' was well in swing. London and other big cities had been evacuated of children; the West Wall, or Siegfried Line, was hurriedly completed. France's Maginot Line was brought back into action, as were the forts on Belgium's border.

Incursions into Germany by the RAF include dropping propaganda leaflets and the only major actions seem to be at sea. The sea war continues apace, with the first two weeks of January 1940 seeing fifty vessels sunk by U-boat, mine and aircraft, as well as collision while in convoy. On 10 January the German commerce raider *Bahia Blanca* even manages to strike an iceberg in the Denmark Strait. Shelled and sunk by HMS *Newcastle*, her crew of sixty-two are all rescued.

Despite the Phoney War in the west, Russia and Finland are slogging it out in the Karelian Isthmus. General Semyon Timoshenko takes command of the Russian forces on 7 January. Retraining and re-equipping his soldiers, he begins a determined attack on the Mannerheim Line. While the attack is in progress, secret negotiations are underway between the Finns and Russians to plan for peace.

On 10 January, an intelligence coup literally lands in the laps of the Allies when a lost German Messerschmitt Bf 108 light aircraft with two officers aboard crash-lands at Mechelen, Belgium. Both men survive but upon discovering they are in Belgium, one tries to destroy papers in his briefcase containing the plans for Fall Gelb, the imminent invasion of the Low Countries. Despite numerous attempts to destroy the plans, they fall into the hands of Belgian intelligence, who manage to convince the Germans that they have been destroyed. Quickly translated, the parts not burned show the plans for the invasion and confirm rumours that an attack is imminent. The French and British are informed and King Leopold personally calls the Dutch and Luxembourg royal families to notify them of the likelihood of the German attack. The intelligence makes the French move their troops next to the Belgian border and they try to pressurise the Belgians into letting them entrench themselves in Belgium in preparation.

Much political wrangling takes place on both sides, with the weather being the ultimate decider. Heavy snow prevents any hope of the invasion taking place and at 1900 on 16 January, Adolf Hitler calls off the invasion. With the plans in

tatters, and the Allies informed of the likely route of the German advance, when it does come, Hitler and his generals change the plan. In May, it will have disastrous consequences for the Allies.

Meanwhile, on 5 February, the Allied Supreme War Council decides to try and stop German iron ore imports from Sweden. These pass through neutral Norway and the port of Narvik, which is ice-free all year round. The iron ore ships sail down the Norwegian coast, and cannot easily be attacked by the Allies without repercussions. An incursion into Norwegian waters takes place on 16 February, when HMS *Cossack* makes the last major boarding action by a Royal Navy crew. The *Altmark* is the tanker assigned to the *Graf Spee*, which had been scuttled in December, and is travelling via the north of Scotland back to Germany. It has been boarded three times by the Norwegian Navy, although each time the 299 British sailors who have been captured by the *Graf Spee* are hidden in the hold. RAF reconnaissance aircraft track the ship. HMS *Cossack* trails the *Altmark* into the Jøssingfjord. Despite a Norwegian escort, *Cossack*'s commander, Vian, orders the crew to board the *Altmark*, fighting with bayonets and cutlasses. The Norwegian forces allow the *Cossack* to leave on the 17th with the 299 British crewmen aboard, giving a huge morale boost to the British at a dark time in the Phoney War.

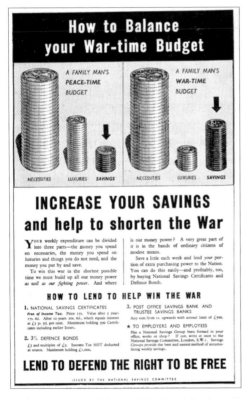
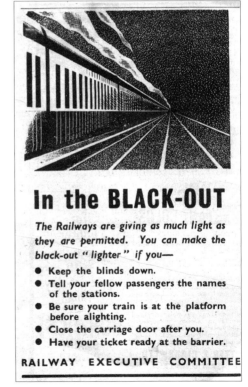

Left: Poster issued by the National Savings Committee to encourage people to invest. 'To win this war in the shortest possible time we must build up all our money power as well as fighting power.' *Right:* Notice concerning the procedures and perils of the blackout on the railways.

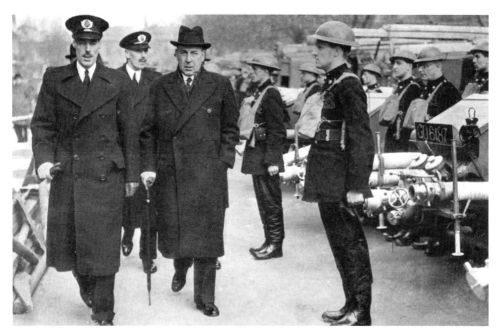

Above: Sir John Anderson, the Minister of Home Defence, inspecting men of the Auxiliary Fire Service lined up with trailer pumps at a station in London. Tasked with preparing Britain's air-raid measures, his name was applied to the ubiquitous air-raid shelters. See page 118.

Five weeks after the calling off of the invasion of Belgium and Holland, the German High Command draws up and agrees to a new plan. General Erich von Manstein suggests an attack through the densely wooded Ardennes region into France's flank, which should take the French by surprise and allow the Germans to attack their weak underbelly. The majority of Germany's tanks will be used in the offensive here. On 11 March, the Finns and Russians agree terms to end the winter war. The Russians will keep their gains in the Karelian Isthmus, as well as Hanko, giving them some 10 per cent of the Finnish territory. The Finns themselves remain undefeated and their casualty rates show just how much better they are than the Russians, with 25,000 troops lost compared to 200,000 Russians.

On 20 March, French Prime Minister Edouard Daladier resigns and is succeeded by Paul Reynaud. Eight days later, Britain and France agree to stick together and not make independent peace treaties. They discuss common goals and on 5 April agree to mine Norwegian waters to force German iron ore shipments in international waters. Three days later, mining is supposed to start but is thwarted by the German invasion of Norway and Denmark. HMS *Glowworm* attacks the German invasion fleet. The tiny destroyer rams the heavy cruiser *Admiral Hipper* but is sunk. A Polish submarine, the ORP *Orzel*, which had managed to escape after the invasion of Poland, has better luck, sinking the transport *Rio de Janeiro*. The *Rio de Janeiro* is carrying 330 troops, seventy-three horses, seventy-one vehicles, flak guns and other supplies. Some 200 die in the sinking.

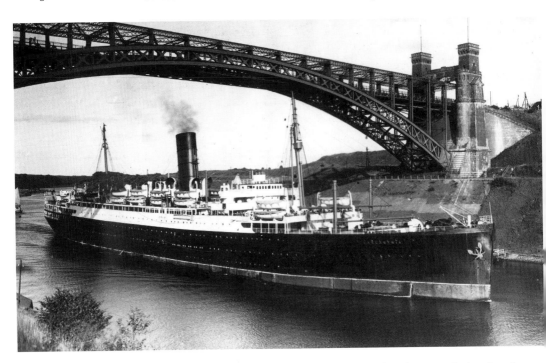

Above: RMS *Lancastria* in the Kiel canal. On 17 June 1940, German bombers attacked and sunk the ship with 9,000 British troops on board. See page 83. *Below:* This British newspaper cartoon questions the USA's continued neutraility following Germany's advances across Europe.

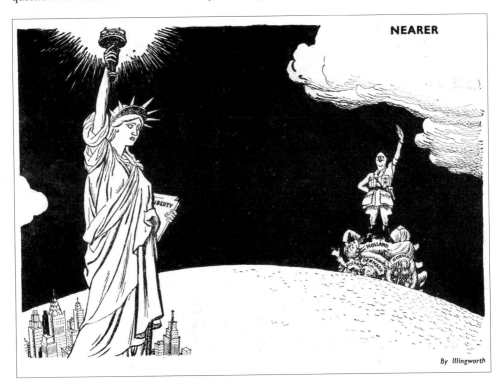

1,000 aircraft fly overhead as the German invasion forces attack Norway and Denmark. Denmark is soon occupied. An airborne assault, the first in history, is made at Stavanger and Oslo airports. The invasion fleet lands troops at six locations, but Norway has no tanks and few artillery pieces. That does not prevent shore batteries at Oslo sinking the cruiser *Blücher*, with 1,600 sailors and soldiers going down with the ship. In the chaos, King Haakon escapes northwards. HMS *Rodney*, one of Britain's biggest ships, takes on the *Gneisenau* and *Scharnhorst*, hitting the *Gneisenau*. Off Kristiansand, the cruiser *Karlsruhe* is sunk by one of her escorting torpedo boats while returning to Germany. Two torpedoes from HMS *Truant* have so damaged her that she was unable to return to port and the Germans decide to sink her.

10 April sees five British destroyers make a surprise attack on Narvik, where ten German destroyers and many merchant ships lie. Each side loses two destroyers but the British sink eight merchant vessels and an ammunition carrier. Meanwhile, in Bergen, the cruiser *Königsberg* is sunk by dive-bombers, the first naval ship in history to be lost in this way. Aerial attacks on the *Gneisenau*, *Scharnhorst* and *Admiral Hipper* fail on the 12th. The next day, British warships again attack Narvik; this time a battleship and nine destroyers venture into Norwegian waters, sinking eight destroyers and a U-boat in the Second Battle of Narvik.

As the British, French and Polish land troops at Namsos, Ålesund and Narvik, between 14 and 19 April, the Germans consolidate their gains and head inland to conquer Norway's mountainous regions. With a lack of winter training, equipment and supplies, the Allies suffer defeat after defeat. They evacuate from Namsos and Åndalsnes on 1–2 May. However, they see some success in Narvik, and the Germans evacuate by the end of April to consolidate. They will return!

It is now that Neville Chamberlain resigns after losing a vote of confidence in the House of Commons. Britain and France are fighting on two fronts as German forces begin attacks in the West on 10 May. After preliminary bombardments and aerial attack, paratroops are landed at the forts at Eben-Emael in Belgium, and in key targets in the Netherlands. With the successful attack comes a movement of British and French troops into Belgium to stop the Germans in their tracks. Exactly as planned by the Germans, their main attack rolls through the Ardennes to the south, straight through Luxembourg and into France. Defence in the Netherlands is already crumbling. The Rhine is mined and floodgates are opened in Holland's dykes. Queen Wilhelmina escapes with the Dutch government on 13 May, and heads for Britain, but not before Rotterdam is severely damaged by bombing. The city capitulates on the 14th, with the rest of Holland surrendering the next day. The Belgians are driven back from the defensive Albert Canal and the Germans are soon up against the French and British armies on the Dyle Plan Line along the rivers Dyle and Meuse.

By 12 May, the Germans are at the Meuse, using dive-bombers to pound French positions on the opposite bank. Bridgeheads are made at Sedan and Dinant after crossings using rubber dingies on the 13th. The rapidly moving German tanks, despite aerial attack, push into France, opening a 50-mile gap between the French

2nd and 9th Armies. Between 15 and 20 May, the Allies are forced back from the Dyle Plan Line to the Scheldt Line. West of Brussels, this new line will soon be overrun. The French have already abandoned Holland while the Belgians continue to fight but withdraw from Antwerp and Brussels, heading for the Escaut Canal, and the Lys River. On the 15th, the RAF bombs strategic targets in Germany, with raids on oil plants and marshalling yards in the Ruhr, using ninety-nine bombers.

Between 16 and 20 May, the French reserves are thrown into the fray, but even they cannot stem the flow of Germans. By 18 May, German panzers are in Cambrai and two days later they have cut off the Allies in Northern France when they reach the English Channel at Abbeville. Tank battles take place at Arras between 21 and 23 May but the Allies are again defeated. Soon, after small-scale evacuations, Boulogne and Calais are surrendered. Some 300,000 Allied troops are caught in a trap between two German armies and are being squeezed. The Belgians are surrounded after the Allies pull out to Dunkirk, one of the few coastal towns remaining in Allied hands. King Leopold surrenders on 28 May, and the Belgian dead total 7,550. With its eastern flank severely weakened, the British have already begun a withdrawal from Dunkirk on 26 May. Pleasure craft, paddle steamers, ferries and destroyers all make the voyage through the shoals and sandbanks to bring soldiers from the harbour. As the harbour is pummelled, with ships burning at the dockside, the troops begin to be evacuated from the beaches.

At the same time, British and French troops begin to be withdrawn from Norway, starting on 4 June. This is when the evacuation known as Operation Dynamo ceases at Dunkirk, after some 338,226 men have been brought back to the UK. Much equipment has been lost but the highly trained men have been rescued. The toll in equipment includes lorries, tanks, supplies, many small arms, 106 aircraft and 243 ships and boats of all sizes, from pleasure craft to paddle steamers and destroyers. 40,000 French remain at Dunkirk and surrender to the Germans on 4 June. The way is open for the Germans to advance deep into France. 119 divisions attack on 5 June at the start of Operation Red. The panzers again strike deep and quickly into France, reaching the Seine by 9 June.

During the evacuation of Norway, HMS *Glorious* is sunk, along with two destroyers by the *Gneisenau* and *Scharnhorst*. The loss of the aircraft carrier is a bitter blow to Britain. Lack of air cover and escort ships is to blame.

At St-Valéry-en-Caux and Le Havre, some 11,000 British troops evacuate to Britain but many are captured as the Germans surround the ports. Compounding the problems of Britain and France, Mussolini declares war on 9 June as France is obviously done for. The Italian dictator hopes to gain in the spoils of war. His dreams are a little shattered on the 12th, when his naval base at Tripoli is bombarded by the Royal Navy, followed by Genoa and Vado on the 14th by the French. On the 13th, Paris is declared an 'open city' and German troops triumphantly enter on the 14th, the French already having withdrawn to south of the capital. The only French troops in the north-east of France are surrounded in the forts of the Maginot Line, bypassed so quickly and easily by the German tanks.

In a ridiculous situation, as British troops are evacuating from Dunkirk, more reinforcements are being pushed into France in early June. A Canadian division and other British troops have been landed in the Cotentin Peninsula but are soon being ordered to retreat back to Cherbourg. Despite the rescuing of a third of a million men from Dunkirk, some 200,000 British and Allied soldiers and airmen still remain in France, pushed westwards in the rush to escape the Blitzkrieg. Operation Ariel is the evacuation of these troops and covers the western ports from Cherbourg to the Biscay harbours of St-Nazaire, La Pallice and Bordeaux, among others. Almost 192,000 more servicemen are rescued this way. But, disaster is to strike at St-Nazaire when German bombers sink the heavily laden RMS *Lancastria*. With upwards of 9,000 on board, she is bombed and sunk. A mere 2,477 survive.

French Prime Minister Paul Reynard resigns on 16 June and is succeeded by Marshal Pétain, who requests armistice terms from the Germans on the 17th. The armistice is signed on 22 June in Compiègne, in the same railway carriage that saw the German treaties signed at the end of the First World War. Germany occupies fully two-thirds of France, including Channel and Atlantic ports, which are soon occupied by submarine flotillas. Vichy France occupies the remainder of the country. Opposition by Free French troops in Britain is led by Charles de Gaulle, a charismatic general, who is soon broadcasting to his countrymen via the BBC.

The Italians attack France from the south in an effort to 'land-grab' some territory and also attack Malta before an armistice is signed with Vichy France on 24 June. In the East, Russia occupies Bessarabia and Bukovina, parts of Romania, while far to the west, the only part of Britain occupied by the Germans, the Channel Islands, is under German rule by 30 June. An evacuation of many civilians has already taken place but many remain behind. Between 1 July and October, the U-boat crews have their 'happy time', sinking many British ships from their new bases in the Bay of Biscay and northern France.

With fears that the French navy, Europe's second most powerful, will fall into German hands, the Royal Navy attacks at Oran and Mers-el-Kebir. French ships in British ports have already been seized but the attacks sink one battleship, damaging two others, as well as inflicting damage on numerous smaller vessels. The majority of the remaining French fleet head for Toulon and the naval base there. The Italian fleet is also a danger and on 9–19 July, the British Mediterranean Fleet attacks, with damage to an Italian battleship and a cruiser. In a war that had turned decidedly against the United Kingdom, Herman Göring takes advantage of the French airfields to start an air war against England. On 10 July, the first concerted attacks are made on ports and shipping along the south coast. Six days later, Hitler outlines the plan for the invasion of Britain, Operation Sealion. It requires Luftwaffe control of the Channel and destruction of the RAF. Peace offers are rebuked by Winston Churchill on 22 July and the invasion is set for later in the summer.

Russia annexes Latvia, Lithuania and Estonia on 21 July, thereby creating a Soviet state from Poland to Siberia. The next day, SOE (the Special Operations

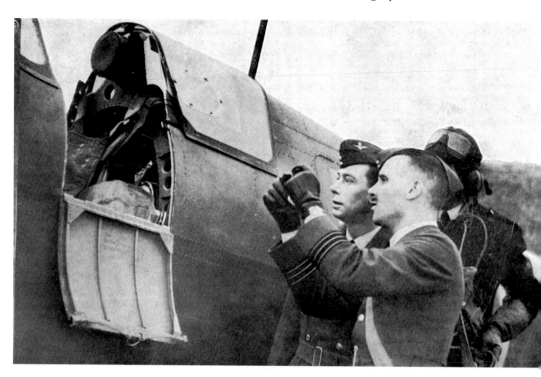

Above: The King is shown over the RAF's latest fighter aircraft, the Spitfire, which first entered service with 19 Squadron at RAF Duxford in August 1938. Although generally perceived to be *the* Battle of Britain fighter, it was the Hawker Hurricane that accounted for the greater proportion of victories against the Luftwaffe. *Below:* Hurricane pilots wait in readiness.

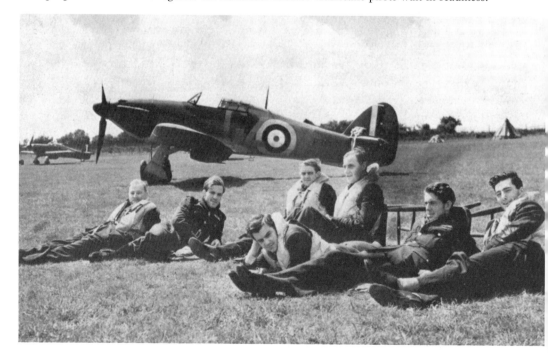

Executive) is set up, its primary purpose to provide supplies, weapons and training for resistance groups across Europe. The Americans, while not in the war, are invoking trade bans and embargoes to prevent the Japanese getting access to raw materials. This encourages the Japanese to look at the natural resources of the Dutch East Indies and Malaya.

Directive No. 17, issued on 1 August, states that the Germans must be ready to invade Britain by 15 September, with the invasion taking place between 19 and 26 September. Barges begin to be moved from inland rivers of Europe towards the Channel ports. In the Med and Africa, Sardinia is attacked by the Royal Navy on 2 August, while the Italians invade British Somaliland via Ethiopia. By 5 August, the preliminary plans for the invasion of Russia are also available. The initial attack is two-pronged, with one army heading for Moscow, the other Kiev.

'Eagle Day' sees the Luftwaffe try to destroy the RAF on the ground and in the air. 13 August will see many attacks on Britain, and two days later, 900 fighters escort 1,300 bombers over England on numerous raids designed to destroy Britain's air defences. Using radar, the 650 available British fighters see off the German attacks. The Germans announce a blockade of Britain on 17 August, vowing to destroy any shipping or aircraft it finds, whether British or neutral. The British fight off more attacks against the 2,800 German aircraft and nearly concede defeat on 24–25 August after numerous losses. The speed at which new aircraft can be built and battle-worn ones repaired is all that keeps the Allies in the war. Of course, downed RAF pilots can be picked up and can fly again but German aircrew who have bailed out over Britain are interned. After a night raid on London on 25 August, the RAF sends eighty-one aircraft to berlin on the evening of 26–27 August. The feat is repeated nightly until the 29th.

The US agrees to supply Britain with fifty outdated destroyers on 2 September. This lifeline means extra naval support for convoy escort duties but the UK has to hand away bases in Bermuda and the Caribbean to the United States. With the Battle of Britain not going Germany's way, the Sealion landings are postponed until 21 September.

Herman Göring's tactic of changing the bombing from the RAF bases to industrial and civilian targets on 7 September is his undoing and the Luftwaffe ultimately loses the Battle of Britain. The night of 7 September sees huge raids on London, with 500 bombers flying overhead, escorted by 600 fighters. Daylight raids are soon abandoned as the scale of the casualty rate increases but the fighting of 15 September is the strongest of the campaign. While the Germans are raiding Britain, Bomber Command are destroying some 10 per cent of the barges required for Sealion. Of Hitler's initial 2,800 aircraft, by the time the Battle for Britain is over at the end of October, he has lost 1,733 aircraft but, more importantly, 3,893 irreplaceable pilots and air crew. The RAF and associated Allied squadrons have lost 828 aircraft and 1,007 valuable pilots.

On 13 September, Italy invaded Egypt from Lybia, with a force of a quarter of a million under Marshal Graziani. Two Italian destroyers and a pair of cargo ships are destroyed at Benghazi by HMS *Illustrious* and *Valiant* on 16 September.

Conscription has begun in Canada, Russia and the United Kingdom. Hitler abandons Sealion on 17 September and begins to look east for new territories to conquer.

Wolf packs make their first Atlantic appearance on 20 September 1940, with U-boat captains reporting good successes against British shipping. Twelve ships are sunk from one convoy alone as some fifteen U-boats descend on it. The Japanese continue their march through Asia by annexing Indo-China on 22 September from the Vichy French, who are powerless to stop them.

The Vichy French are not powerless elsewhere, as they repel an attack by British and Free French forces in Senegal on 23–25 September. Dakar is attacked and the Vichy lose a destroyer and two submarines. The Vichy French air force attacks Gibraltar as retaliation for the Dakar raid. September ends with the Germans, Italians and Japanese making a tripartite agreement in an attempt to prevent US intervention in the war.

Romania is occupied by Germany on 7 October in a blatant attempt to capture the Ploesti oilfields. Five days later, Sealion is postponed until the spring. The Dutch in the East Indies agree to supply Japan with huge quantities of oil on 19 October and the Italians decide not to tell Germany that they are going to invade Greece

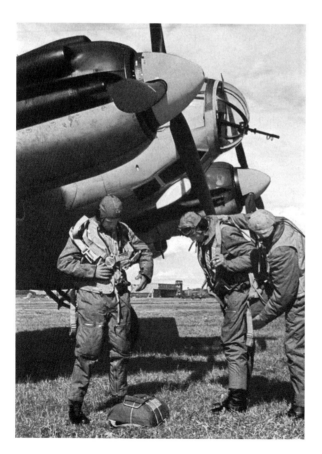

Left: The crew of a Heinkel He 111 prepare for another mission. This medium bomber had seen action in the Spanish Civil War and went on to become the primary Luftwaffe bomber in the Battle of Britain.

at the end of the month. Stiff resistance is put up against the Italians, who find the going tough. Britain invades the strategic island of Crete on 30–31 October.

November is a month of both triumphs and disasters for Britain. The pocket battleship *Admiral Scheer* is on the loose and comes up against a convoy headed by the armed merchant cruiser *Jervis Bay*. With her tiny 6-inch guns, the *Jervis Bay* orders her convoy to scatter and takes on the huge guns of the *Scheer*. Thanks to the plucky little liner, which is rammed and sunk, only five of thirty-seven ships are lost. All convoys are cancelled until the whereabouts of the *Admiral Scheer* are known. Taranto goes down in history as one of the most daring raids of the war. Swordfish torpedo bombers from HMS *Illustrious* make a daring night-time raid on the Italian naval base, sinking three battleships for the loss of two aircraft. As the Italian fleet moves to 'safer' bases in Naples and Genoa, a British fleet of three cruisers sinks four ships in the Strait of Otranto. Japan takes note of the success of the aerial attack on the naval base and copies the idea.

The Greeks, with British help, repel the Italians almost to the Albanian border between 14 and 22 November but, while the Greek fight-back begins, 500 bombers raid Coventry, flattening parts of the city, causing 500 deaths and destroying the city's cathedral. Radar, which saw the UK win the Battle of Britain, is used successfully on 18 November to hunt a U-boat. Two days later, Hungary joins the Axis forces, and a mere three days after this, Romania also joins forces with the Axis powers. In what will be one of the biggest and most senseless wastes of lives of the war, the beginnings of the 'Final Solution' are created in Warsaw, as many tens of thousands of Poland's Jews are forced into a ghetto in the city.

After his force's mauling in Greece, Italy's Marshal Pietro Badoglio resigns on 6 December. Three days later, Britian begins an offensive against the Italians in the Western Desert. 31,000 British and Commonwealth troops attack and have soon captured 34,000 Italian troops. On 18 December, the plans for Operation Barbarossa are well in hand. Hitler's plan for the invasion of Russia, Directive No. 21, sets out a three-pronged attack, with the biggest weight on the route to the Baltic and Moscow. The month ends for many Italians in desert prisoner of war camps, or freezing to death in the Greek mountains. The Germans are seeing a 'happy time' at sea, sinking hundreds of thousands of tons of Allied shipping, while having control of most of Western Europe and much of Central Europe too. Britain, however, ends the year with its back to the wall, attacked on all fronts. Its ships are being sunk faster than they can be built, its cities are being pounded by night by German bombers and it stands alone in Western Europe against the Germans and Italians. President Roosevelt, recently elected for a third term, gives some comfort in his pledge that the USA will become the 'arsenal of democracy', supplying British and her allies with aircraft, ships, ammunition and other vital supplies.

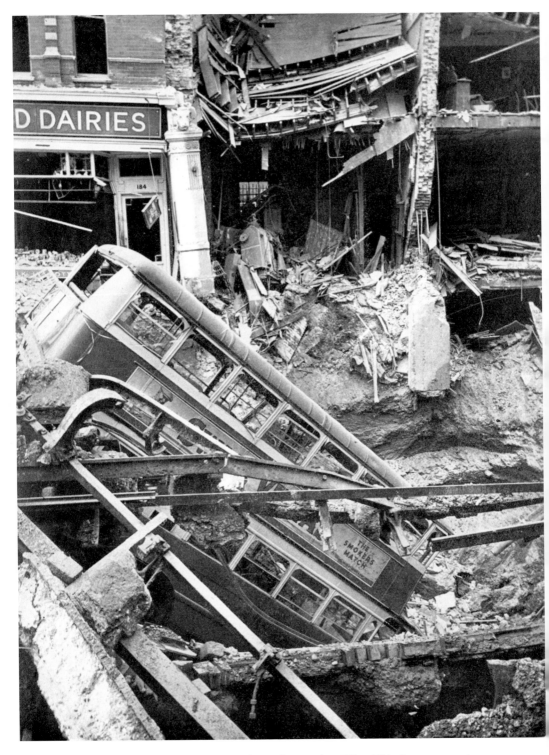

Above: A typical scene of destruction from the London Blitz. This bus was on its way to Vauxhall and fell into a crater after a bomb had landed in the road barely 25 yards ahead.

JANUARY 1940

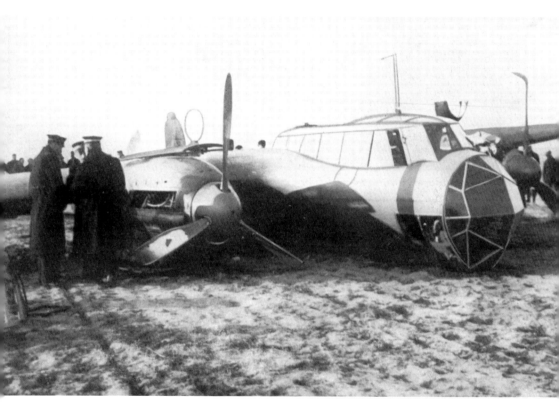

Above: An early trophy, this Dornier Do 17 light bomber was brought down in northern France. The Do 17 was nicknamed the Fliegender Bleistift, the 'flying pencil', because of its long, slender fuselage. The aircraft had seen action in the Spanish Civil War, but production ceased in 1940 and it was superseded by the more powerful Junkers Ju 88 and the Do 217.

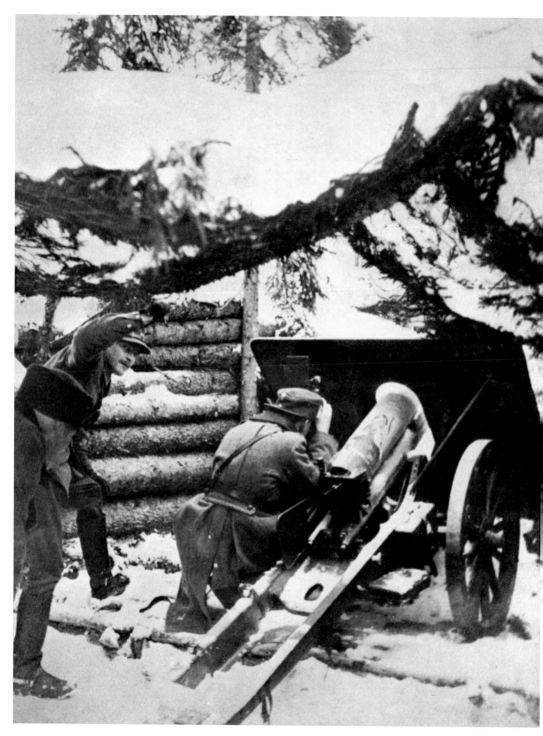

Above: Finnish artillery in action on 30 December 1939. The northern army had destroyed a Soviet division of some 15,000 men near Lake Kianta. The fighting in Finland continued into the new year until February, although secret peace negotiations had commenced by late January.

Above: Finnish soldiers removing a field gun left behind by the fleeing Soviet forces after the Finnish victory at Suomussalmi, near Lake Kianta, on 8 January.

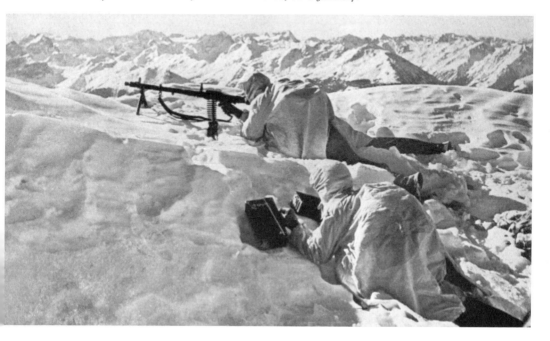

Above: These are men of the German mountain army fighting in the Alps near the French frontier. They are wearing white like the Finnish troops as a camouflage in the snow.

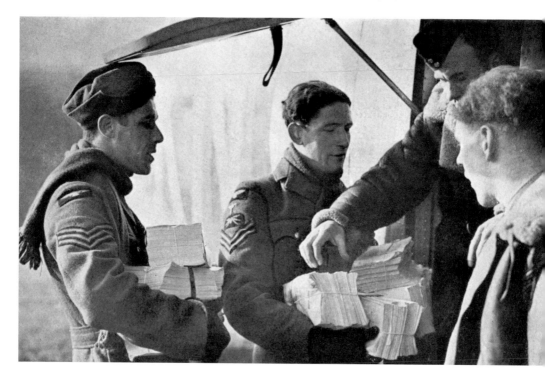

Above: On 12 January, RAF Wellingtons dropped leaflets over Vienna and Prague during a reconnaissance flight above Austria, Bohemia and Germany. Some of the airmen who took part in the mission are shown below. It wouldn't be long until the leaflets were replaced by bombs.

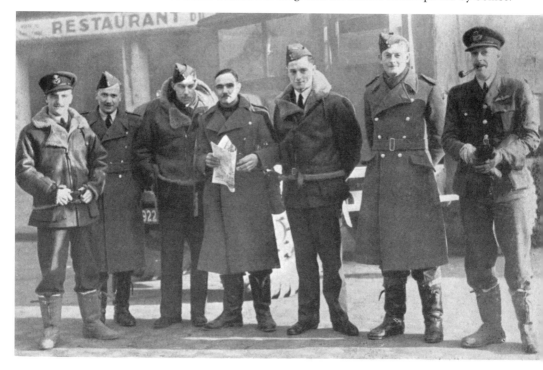

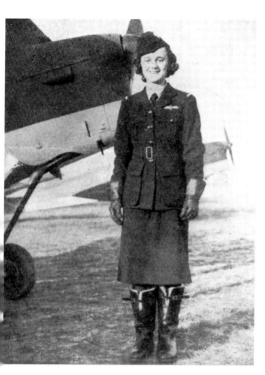

Formed in 1939, the main duty of the Women's Section of the Air Transport Auxiliary Service was to ferry newly built aircraft from the factories to the airfields where they were needed. *Above:* Uniform and flying gear of the ATAS. *Below:* Members of the ATAS on an airfield.

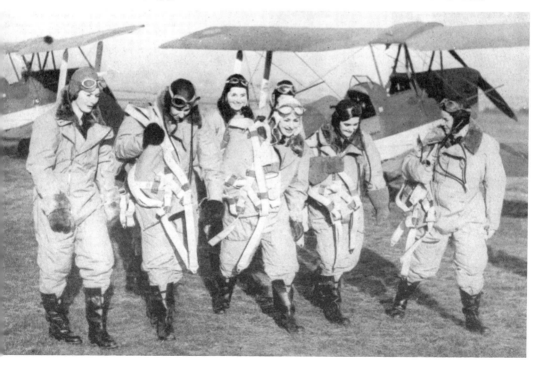

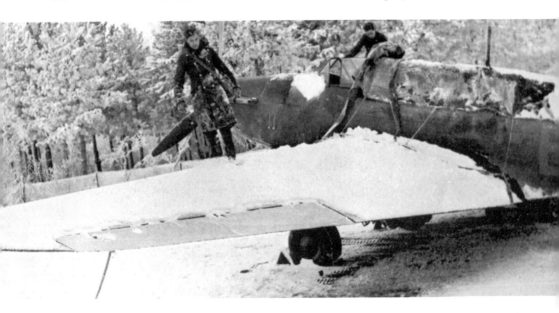

The exceptionally cold winter and record snowfalls created difficult conditions for both sides, causing a delay in the expected onslaught. *Above:* Mechanics clear snow from the wings of a Fairey Battle at an airfield in France. *Below:* A sentry guards a camouflaged aircraft.

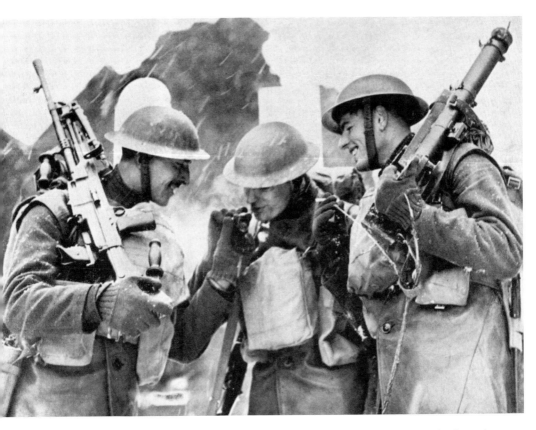

The freezing conditions lasted on the Western Front until March, and photographs from this stage of the war bear a striking resemblance to those of the First World War. Welsh Guards are shown relaxing with a cigarette, above. The soldier on the right is carrying a 2-inch mortar. *Below:* Playing football to keep themselves warm.

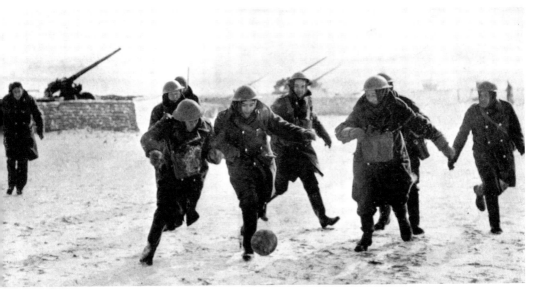

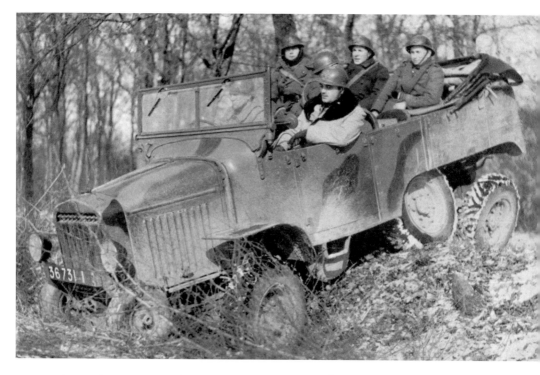

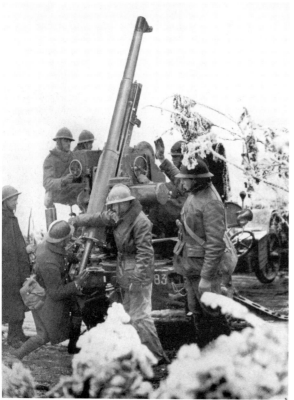

Above: An interesting all-terrain vehicle operated by the French army. The wheels operate and move independently of each other, and the small pair at the front prevent it from digging into the side of a ditch. It is a hefty piece of kit to transport just six men and it most probably served as a gun tractor.

Left: A French anti-aircraft gun being readied to fire on the Western Front.

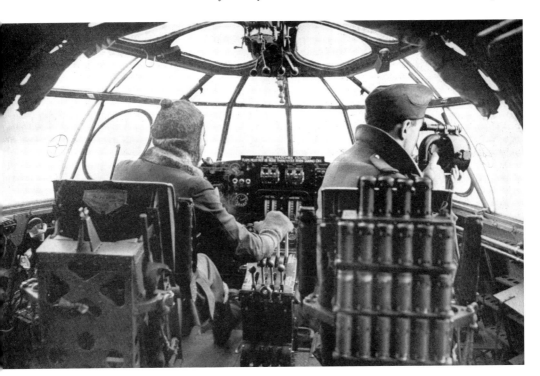

RAF Coastal Command maintained a constant watch for U-boats and other enemy craft. Shown above, the pilot and second pilot of a Short Sunderland flying boat on coastal patrol. These long-range maritime aircraft were adapted from the Empire flying boats of the interwar years, and they had a range of 1,700 miles. *Below:* Smaller, twin-engined Lerwicks under construction. These were introduced into service in 1940.

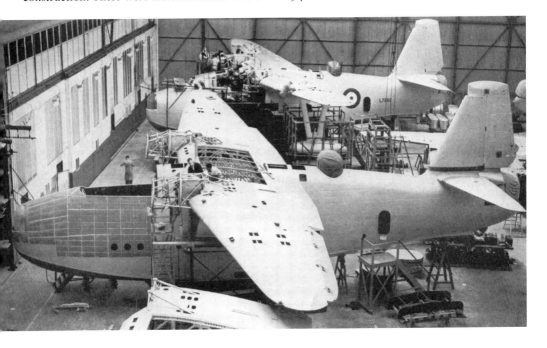

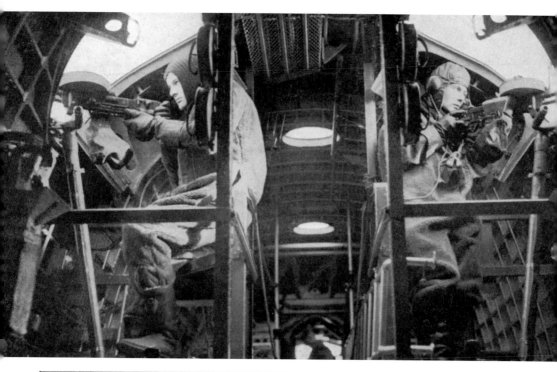

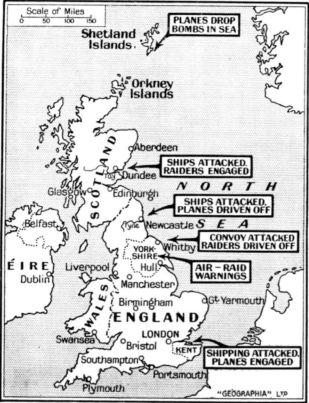

Above: Aboard a Sunderland flying boat, two gunners at their action stations, facing outwards on either side of the fuselage.

Left: Map showing the locations of Luftwaffe raids on coastal targets on 19 January 1940.

Opposite page: While on patrol over the North Sea, the aircraft's navigator works on his charts. The lower image shows the captain taking a message from the radio operator. Transmissions were received from Coastal Command headquarters in coded form. Note that the crew of the flying boats were permitted to smoke while on patrol.

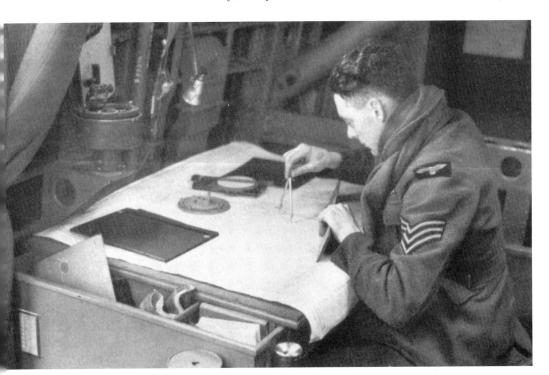

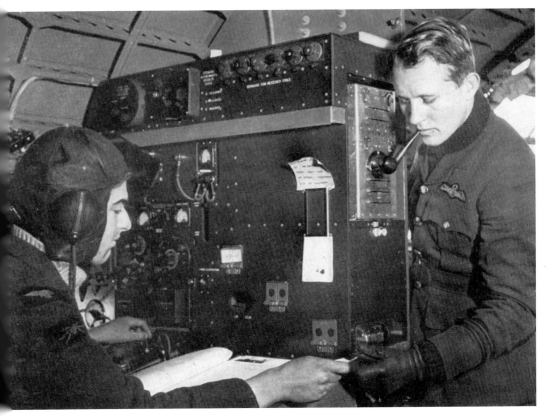

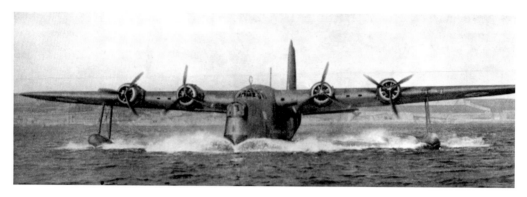

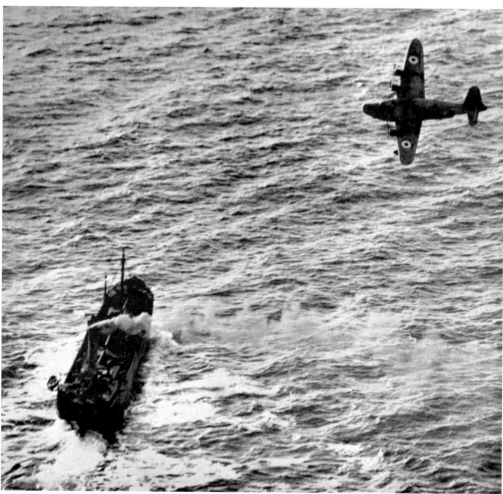

RAF Coastal Command Short Sunderland flying boat in action. The largest aircraft operated by the RAF, it was powered by four 1,000-hp Bristol Pegasus engines to give the machine a maximum speed of 210 mph. It is shown in the lower photograph circling around a merchant vessel in order to confirm its identity. Because they could land on the water, given the right sea conditions, Coastal Command flying boats were also used to rescue downed airmen.

FEBRUARY 1940

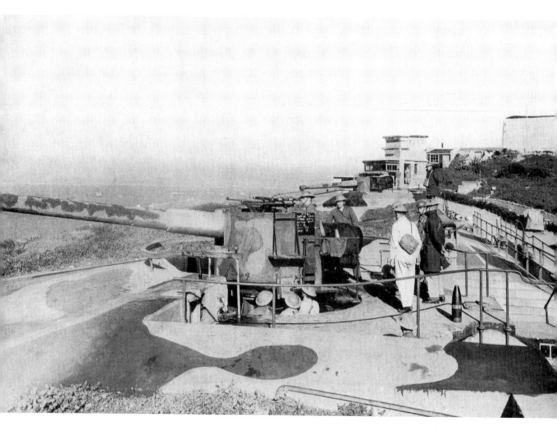

Above: Overlooking the Strait, one of the large coastal guns on the Rock of Gibraltar. It is manned and ready for action. During the Second World War the civilian population was evacuated, mostly to London, and the rock was fortified as a fortress. Franco's reluctance to let German forces into Spain frustrated Hitler's plan to capture this strategically important British territory.

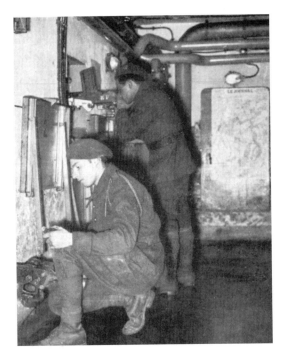
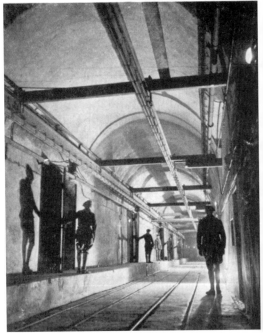

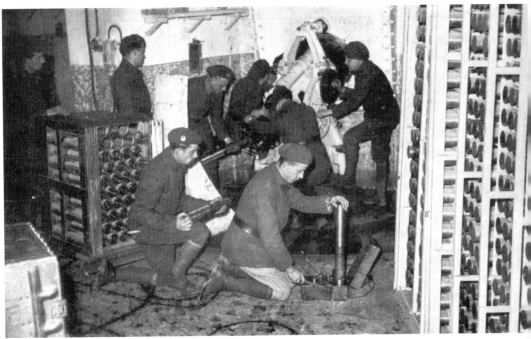

France's faith in the Maginot Line, the string of forts and defensive positions along the frontier, would soon prove to be misplaced when the Germans invaded through the Low Countries to effectively outflank the fortifications. But at the beginning of the year it was still manned, as these photographs show. In the lower photograph French gunners are loading one of the guns in a fortified emplacement. A rack of shells is seen on the right-hand side.

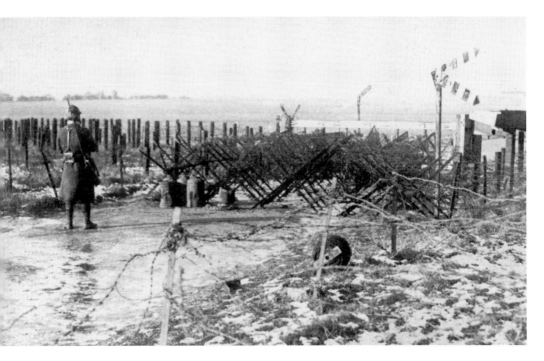

Above: Barbed wire entanglements and trenches on the front line in northern France. These relics of a former war would not stop the Germans. The Blitzkrieg was to be a fast-moving tidal wave of superior force, mobile, highly mechanised and with fully integrated airborne support. *Below:* The British Expeditionary Force included these men of the Hampshire Regiment.

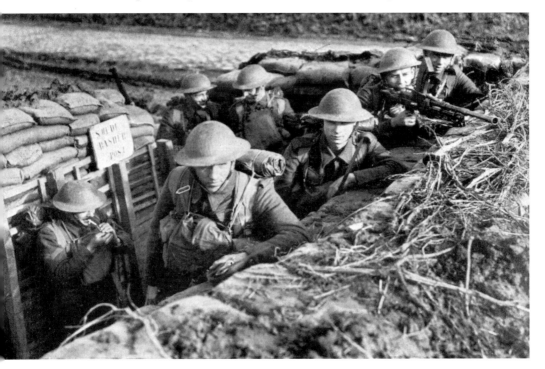

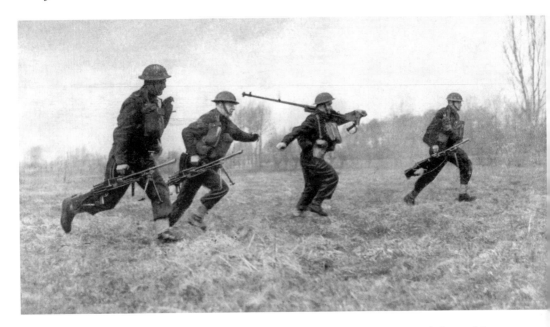

'Three Bren gunners and an anti-tank gunner of the Loyal Regiment, North Lancashire, seen making a dash forward during training at the front.' These photographs, taken in France during the first few months of 1940, are typical of the propaganda published in Britiain as reassurance that the BEF was prepared and ready for action. *Below:* Infantrymen with field radio.

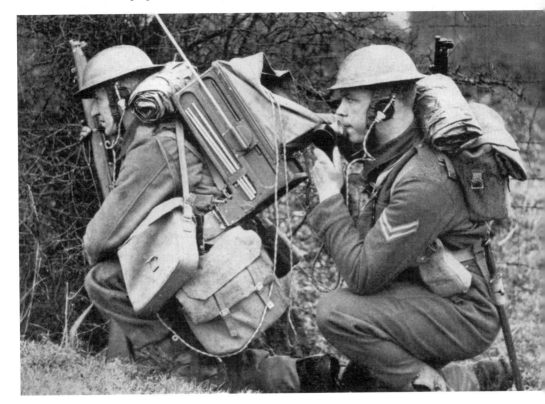

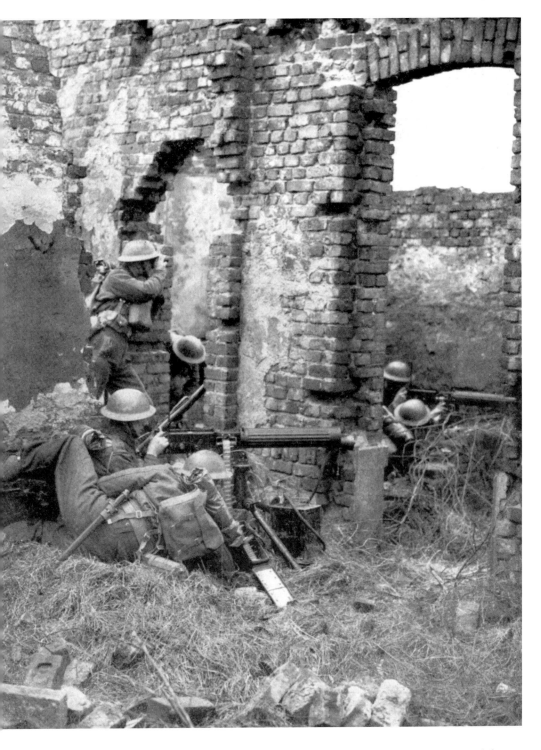

Above: Troops of the Cheshire Regiment taking positions with their machine guns, in ruins left from the previous war.

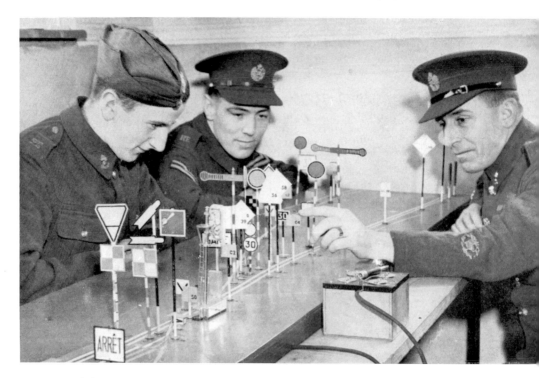

Men of the Royal Engineers undergo training in the Continental railway systems so that they will be ready to transport troops, ammunition and essential supplies to the Western Front. *Above and bottom left:* Learning to work the railway signals using models. *Bottom right:* Practical training in the working of the steam locomotives is carried out by dismantling and reassembling redundant British locos in the workshop.

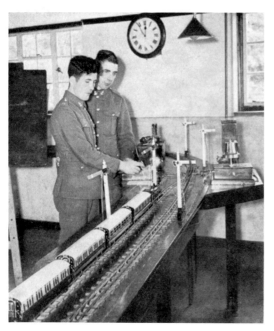

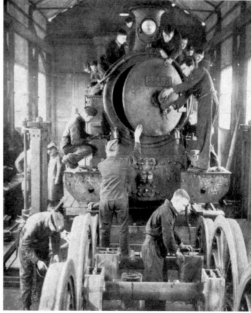

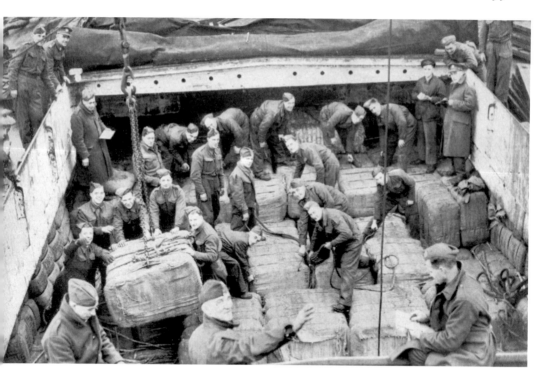

The supplies going across the Channel took an unexpected form. Here members of the Military Pioneer Corps serving in France are hard at work in the hold of a cargo vessel in a French port. They are unloading thousands of empty sandbags into a railway truck. Once filled, the sandbags will be used to strengthen trenches and emplacements.

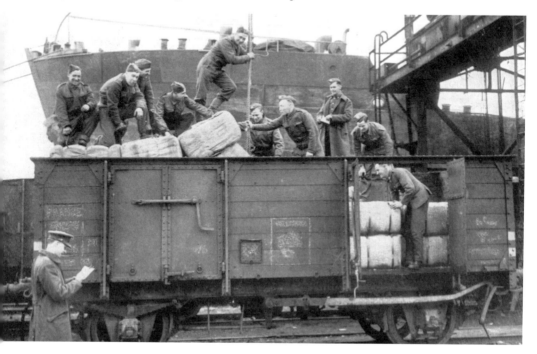

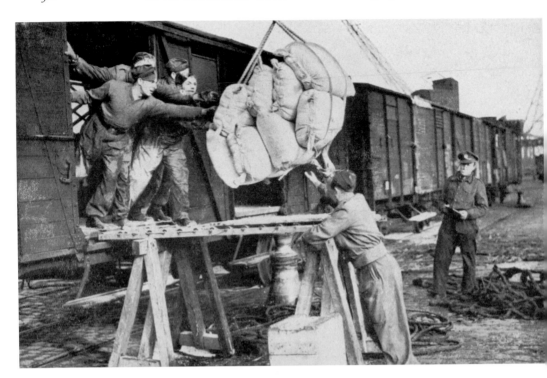

To feed the growing army, sacks of flour are unloaded by members of the Military Pioneer Corps at a railhead in France. The MPC dealt with the movement of all consignments of food to the BEF. *Below:* Kneading vats of dough in the bakery to make thousands of loaves daily.

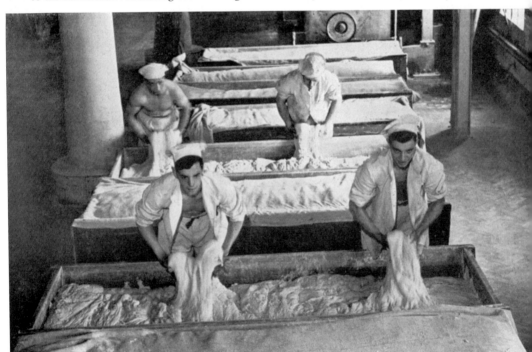

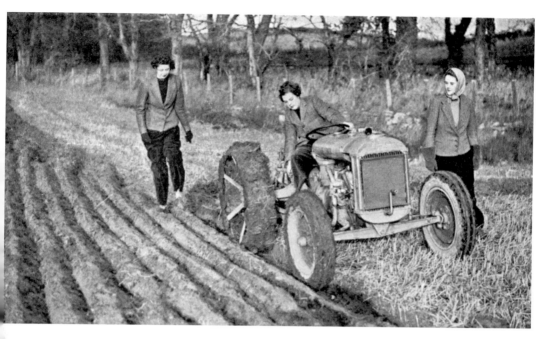

The supply of food was essential not only for the armed forces, but also for the civilian population. The Women's Land Army volunteers were given training at approved farms and at official training centres. About 1,000 women were sent for training in the autumn of 1939.

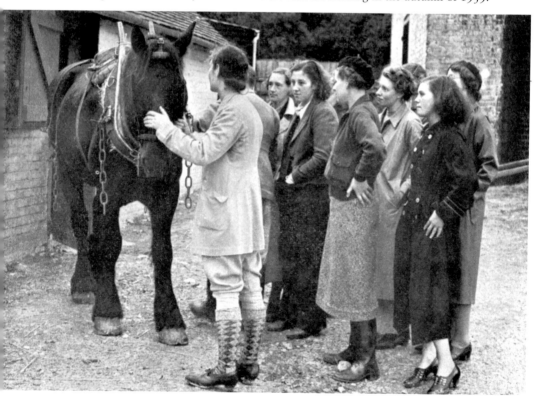

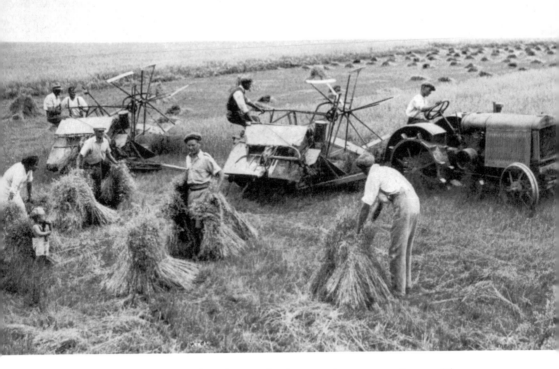

Mechanisation was still a relatively new development in many rural areas. The women were trained to drive the 'motor ploughs' as well as undertaking maintenance and general repairs.

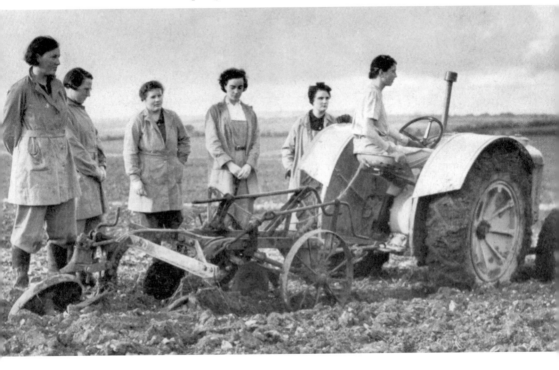

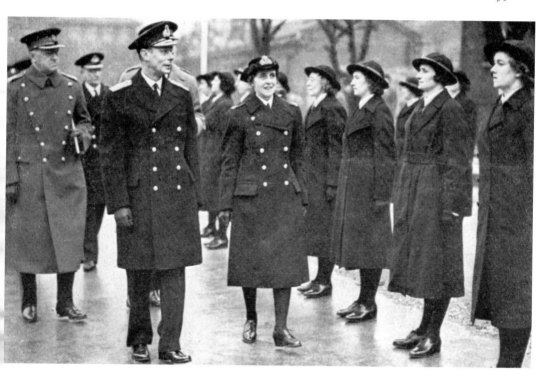

The King and Queen were constantly engaged in inspecting all branches of the services as well as being members of the Civil Defence organisations. King George is shown visiting the Wrens at Chatham on 21 February, while the Queen is on a visit to Edinburgh on the 25th.

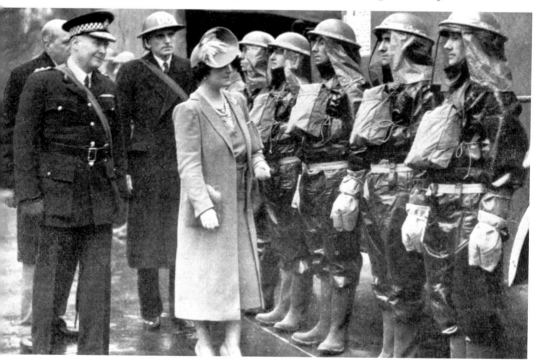

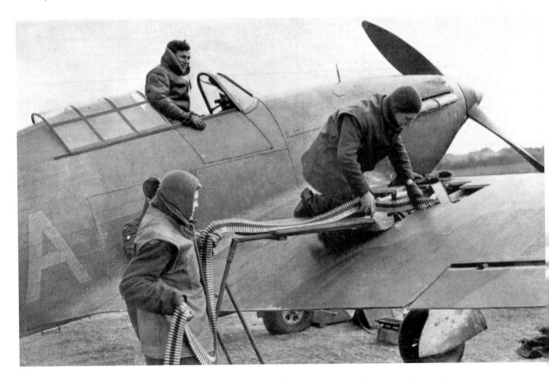

Above: RAF ground staff loading a belt of bullets into a Hurricane's machine gun at an airfield in France. *Below:* To the east of the Siegfried Line a similar scene is taking place as a Messerschmitt Bf 109 is prepared for action. This was one of the first truly modern fighter/interceptor aircraft, and almost 34,000 airframes were produced by the end of the war.

Downed enemy aircraft provided invaluable material for the propagandists on both sides of the conflict, especially in the early stages of the war before they became commonplace. *Above:* A wrecked Messerschmitt Bf 109 brought down by French anti-aircraft fire being examined by soldiers. *Below:* This example, quite possibly the same aircraft, was put on display in Paris.

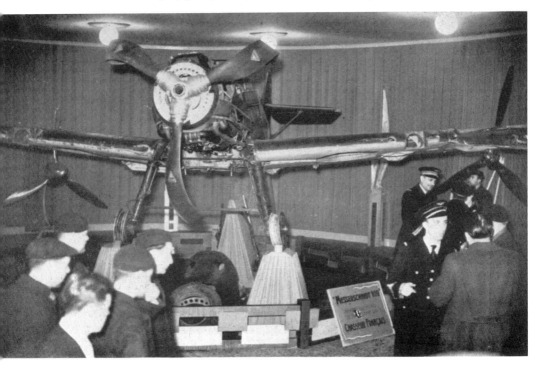

Training new pilots and personnel was a priority for a rapidly expanding airforce. *Above:* A student airman of the Royal Canadian Air Force (RCAF) is learning about an aircraft's controls in this Link trainer. It may look comical, but the Link trainers were effective in duplicating the real thing. *Below:* RAF students preparing to leave on a trial reconnaissance flight during training. The observer is testing his oblique camera. Similar large-format cameras were fitted within the belly of aircraft to obtain reconnaissance photographs looking straight down.

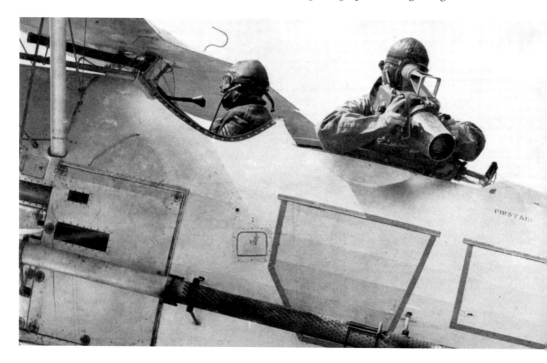

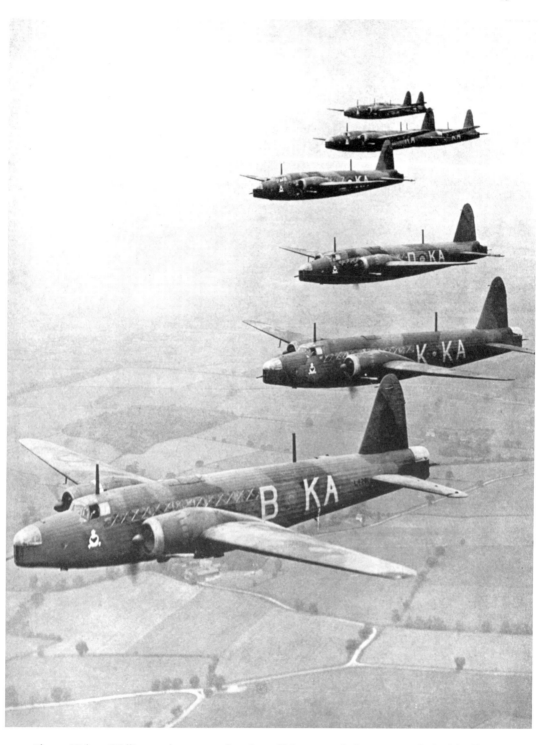

Above: Vickers Wellington long-range bombers. Using a geodesic structure devised by Barnes Wallace, the twin-engined Wellington was introduced into service in October 1938 and was widely used in the early years of the war to drop both leaflets and bombs on enemy territory.

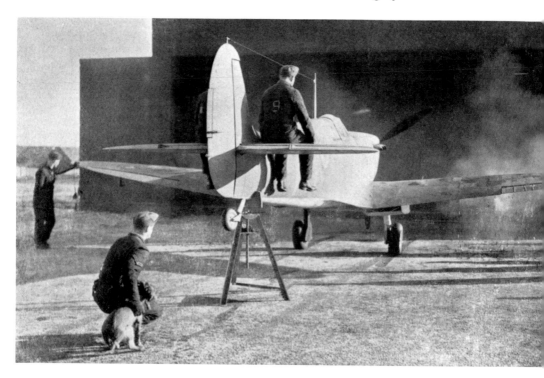

Above: Test-firing a Spitfire's machine guns. Mounted within the wings, these were aligned so that the fire converged at a fixed distance ahead of the aircraft. *Below:* Loading a long, snake-like belt of cartridges into the underside of the Spitfire's wing. Introduced in August 1938, over 20,000 Spitfires were built and some remained in service with the Irish Air Corps until 1961.

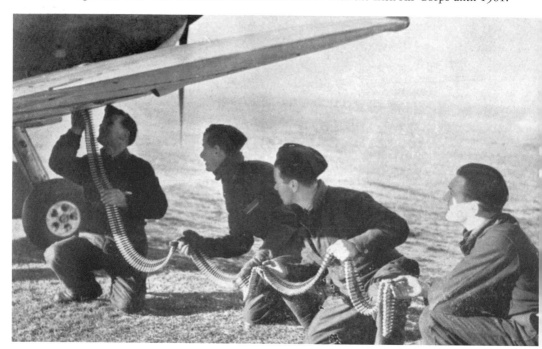

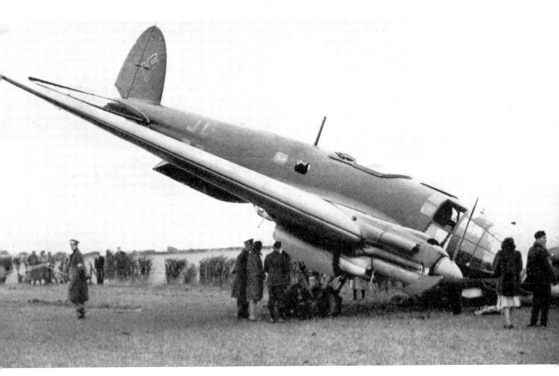

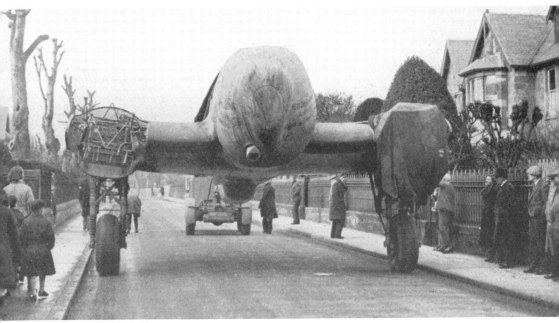

Above: This Heinkel He 111 made a forced landing at Berwick after being intercepted by a Spitfire near the Firth of Forth on 9 February 1940. In the lower image it is shown being manoeuvred through the streets of North Berwick, much to the amazement of the onlookers, on its way to the Turnhouse Airfield in Edinburgh. It was the second Heinkel to be brought down on British soil; the first had also been in East Lothian, at Humble, in October 1939.

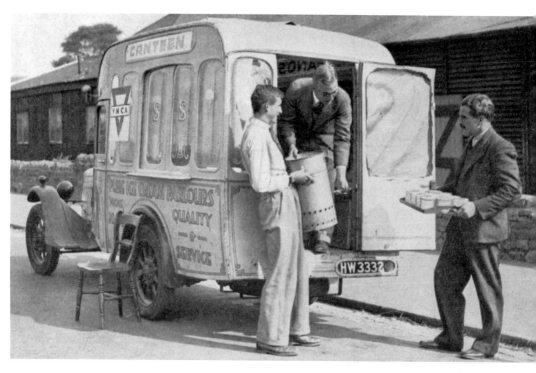

Above: Loading supplies into a YMCA canteen. The YMCA provided servicemen with refreshments as well as cigarettes and reading material. *Below:* The King and Queen inspect an ambulance provided by the Empire to the Red Cross and St John Ambulance organisations.

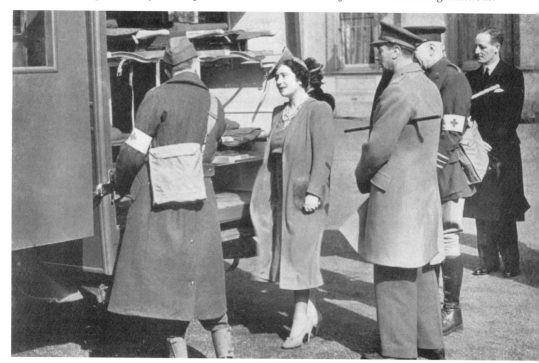

MARCH 1940

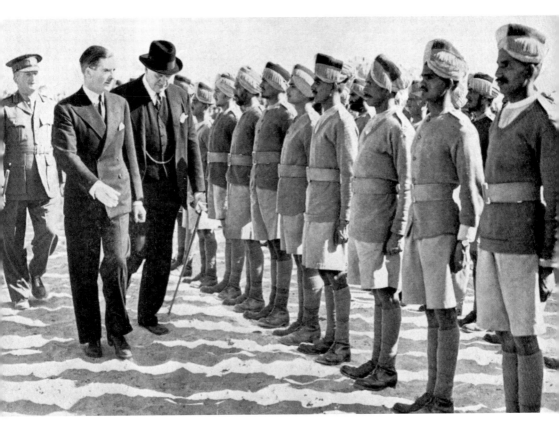

Above: Anthony Eden, the Secretary of State for Dominion Affairs, inspects Indian troops stationed in Egypt, at their camp near the pyramids. Large numbers of overseas troops, primarily from Canada, Australia, New Zealand and India, played a cruicial role in the fighting. The Indian contingent had been the first Empire soldiers to arrive in the Middle East.

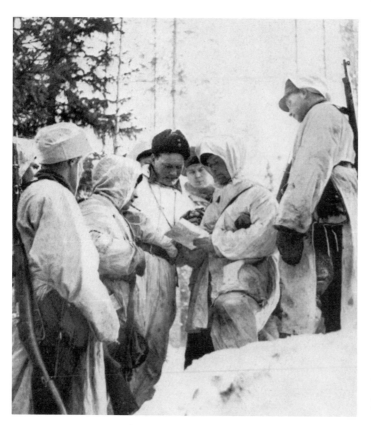

On 15 March the Finnish government conceded to the Soviet's peace agreement. These Finnish troops, left, are reading the conditions of the peace treaty. They were fighting in Viipuri (Viborg), which was to become Soviet territory.

Below: Finnish citizens are shown making preparations to hand Viborg over to the Soviets. They are removing the signs and packing their possessions as they leave their homes.

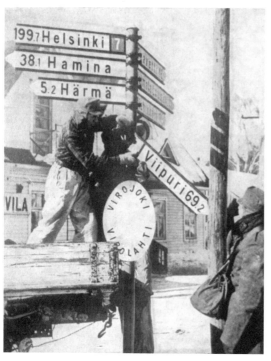

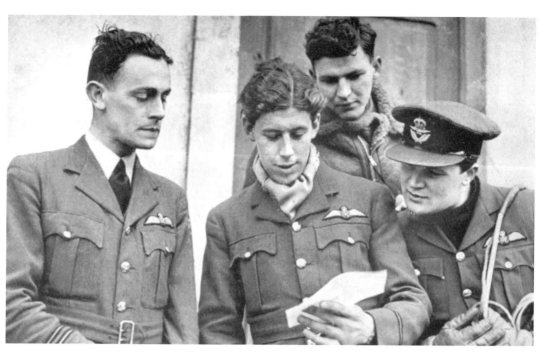

Above: Flying-Officer Edgar James Kain, a New Zealand pilot serving with the RAF in France, reads a congratulatory telegram after shooting down his fifth enemy aircraft. He was later awarded the Distinguished Flying Cross. *Below:* Pilots who took part in an air battle over the Western Front on 26 March examine a captured German machine gun.

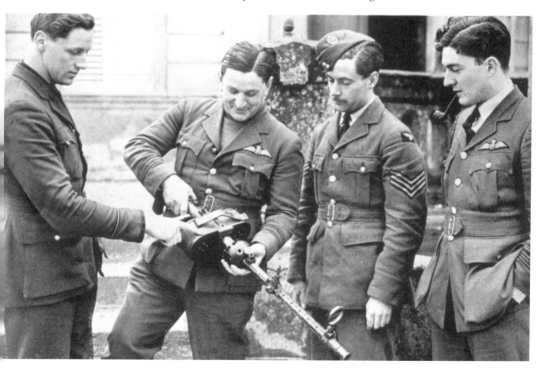

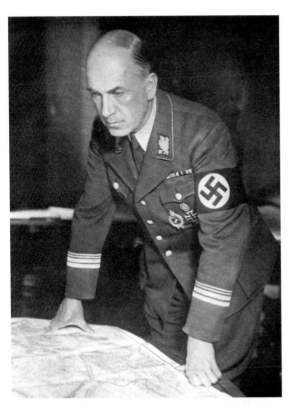

On 20 March Hitler appointed the civil engineer Fritz Todt as the new minister of armaments and munitions production. Todt had made his name as the head of the Organisation Todt, constructing Germany's Autobahn network and the Siegfried Line defensive fortifications. In that role he was responsible for the biggest labour force within the Reich, and also had control of the allocation of scarce materials. The production of armaments was the focus of the almost unseen industrial war and it was this, together with the supply of materials and fuel to feed the war machine, that ultimately would decide the the outcome of the Second World War.

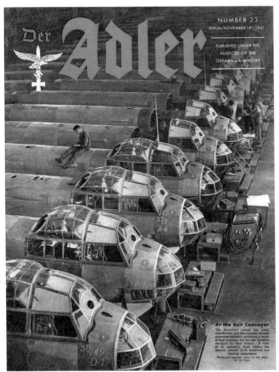

Left: The cover of *Der Adler*, the Luftwaffe's propaganda magazine, showing a row of Ju 88 multi-role aircraft in production. This edition was published in November 1941 and the caption states: 'The Bolshevist enemy has been overthrown, but the German aircraft industry continues to work at high pressure for the last decisive victory. A view of the assembly shed where the famous Junkers Ju 88 bombers are nearing completion.' Introduced in 1939, over 15,000 Ju 88s had been built by the end of the war.

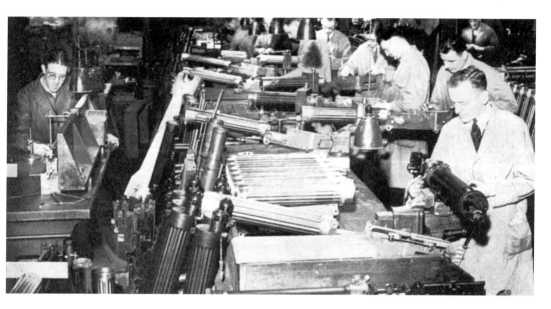

Two images of British munitions workers producing weapons to equip the army. *Above:* Manufacturing Vickers machine guns. *Below:* Making Lee-Enfield .303 rifles. Used in a number early twentieth century, this became the standard rifle for British and Empire forces in the Second World War, with over 17 million built over its operational lifetime.

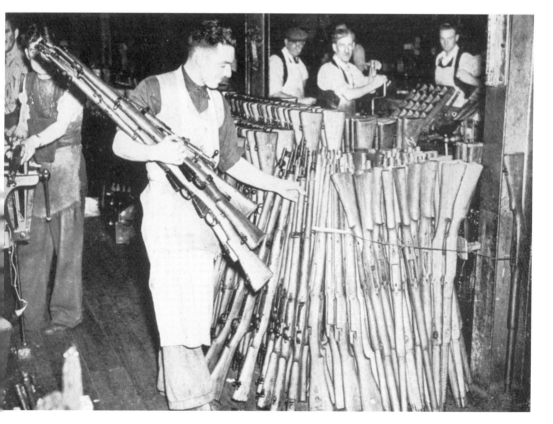

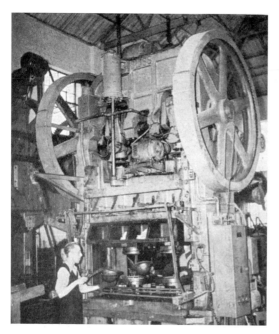 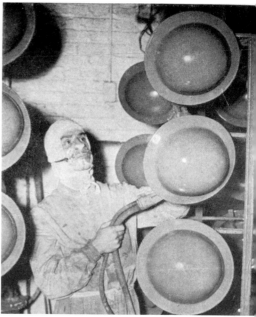

It wasn't all about guns. Millions of stainless steel helmets were needed. After the helmet had been cut and pressed into shape, the rim was clinched and secured in the machine, top left. The helmets were then spray-painted, above right. *Below:* Final inspection of the completed helmets. This factory was turning out 50,000 in a week. They are being inspected before delivery for final testing.

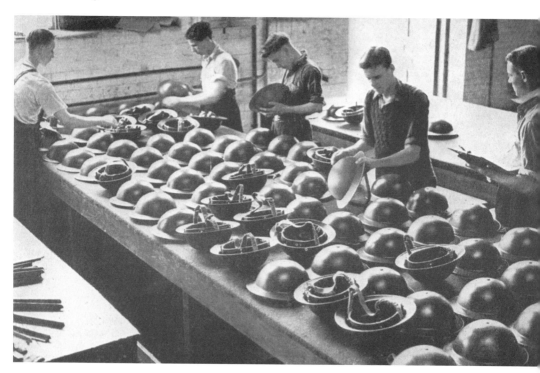

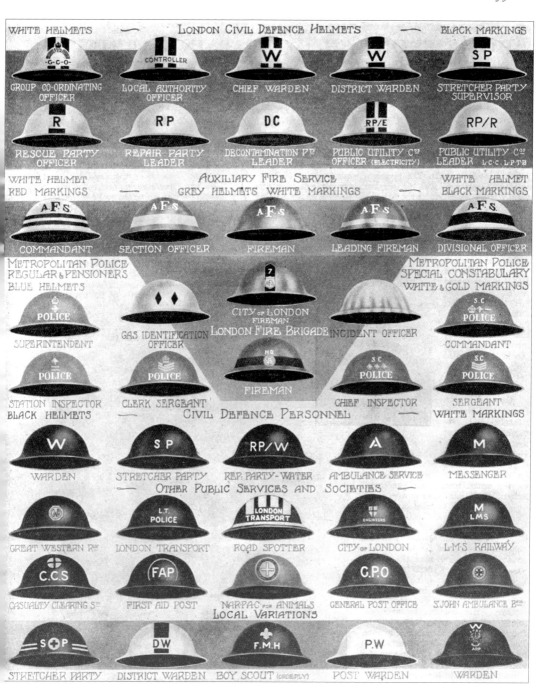

WHITE HELMETS — LONDON CIVIL DEFENCE HELMETS — BLACK MARKINGS

| GROUP CO-ORDINATING OFFICER | LOCAL AUTHORITY OFFICER | CHIEF WARDEN | DISTRICT WARDEN | STRETCHER PARTY SUPERVISOR |
| RESCUE PARTY OFFICER | REPAIR PARTY LEADER | DECONTAMINATION P'Y LEADER | PUBLIC UTILITY Cos OFFICER (ELECTRICITY) | PUBLIC UTILITY Cos LEADER L.C.C. L.P.T.B |

WHITE HELMET RED MARKINGS — AUXILIARY FIRE SERVICE GREY HELMETS WHITE MARKINGS — WHITE HELMET BLACK MARKINGS

| COMMANDANT | SECTION OFFICER | FIREMAN | LEADING FIREMAN | DIVISIONAL OFFICER |

METROPOLITAN POLICE REGULAR & PENSIONERS BLUE HELMETS — METROPOLITAN POLICE SPECIAL CONSTABULARY WHITE & GOLD MARKINGS

| SUPERINTENDENT | GAS IDENTIFICATION OFFICER | CITY OF LONDON FIREMAN — LONDON FIRE BRIGADE — INCIDENT OFFICER | | COMMANDANT |
| STATION INSPECTOR | CLERK SERGEANT | FIREMAN | CHIEF INSPECTOR | SERGEANT |

BLACK HELMETS — CIVIL DEFENCE PERSONNEL — WHITE MARKINGS

| WARDEN | STRETCHER PARTY | REP. PARTY - WATER | AMBULANCE SERVICE | MESSENGER |

OTHER PUBLIC SERVICES AND SOCIETIES

| GREAT WESTERN R'Y | LONDON TRANSPORT | ROAD SPOTTER | CITY OF LONDON | L·M·S RAILWAY |
| CASUALTY CLEARING S'n | FIRST AID POST | NARPAC FOR ANIMALS | GENERAL POST OFFICE | S.JOHN AMBULANCE B'de |

LOCAL VARIATIONS

| STRETCHER PARTY | DISTRICT WARDEN | BOY SCOUT (ORDERLY) | POST WARDEN | WARDEN |

Above: The helmets didn't only come in khaki green, thanks mainly to the multiple variations required for the Civil Defence services. Each had its own distinctive colourings and markings to aid recognition, as shown in this chart. In the fourth row from the top it should be noted that the Gas Identification Officer's helmet was yellow with diamonds in black, while that of the Incident Officer had a light blue cloth cover tied over it.

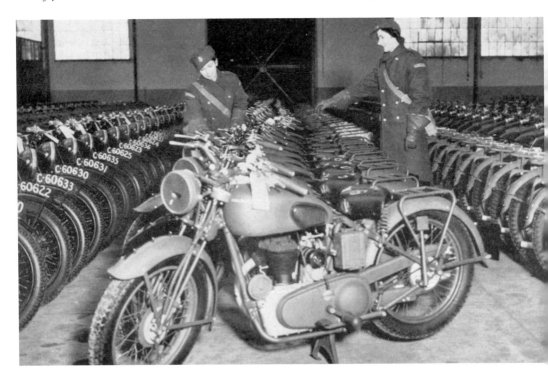

This was also the war of mechanised mobility. *Above:* Drivers of the Auxiliary Transport Service inspecting a new consignment of 2,000 motorcycles at the Royal Army Service Corps depot. These were for the use of dispatch riders with the BEF in France. *Below:* A mobile ARP company in Kent. Duties included accompanying ambulances and demolition squads to bombed areas.

Above: A motorcycle detachment of the Royal Scots Fusiliers. 'Modern war calls for mobility and the armed motor-cyclist plays an important part.' *Below:* An improvised river patrol, organised by workers at a riverside factory.

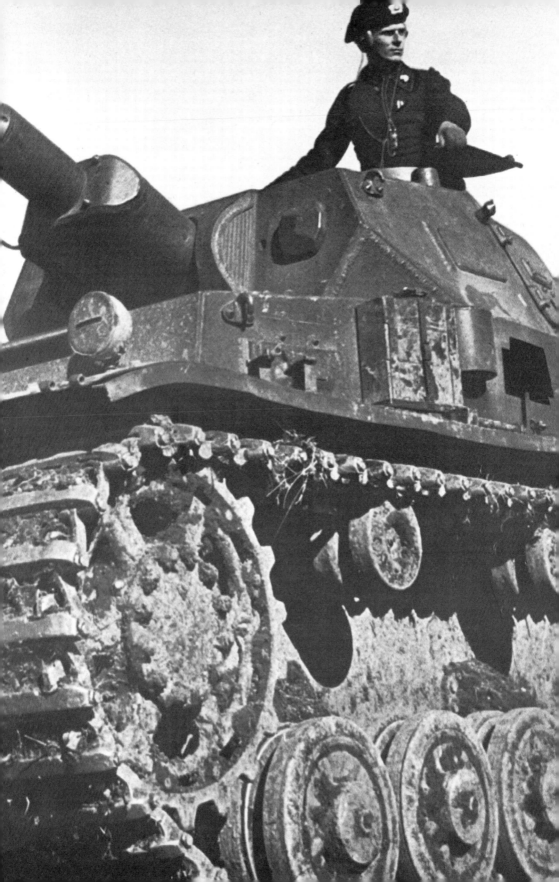

APRIL 1940

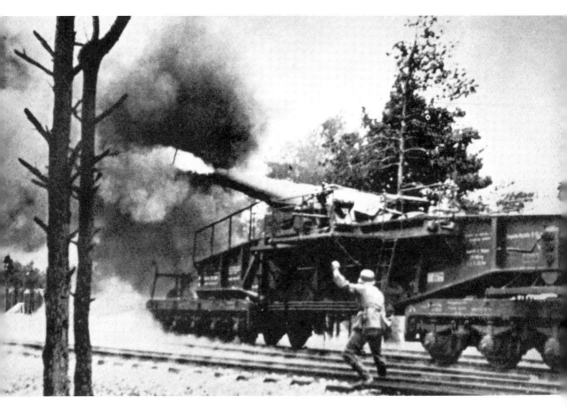

Above: One of Germany's large artillery guns. Using the railway system these huge guns were brought to bear in the early stages of the advance across northern Europe.

Opposite page: A dramatic photograph of a German Panzer. The tanks were essential for Blitzkrieg warfare, and the countryside in the Low Countries was suited to tank warfare.

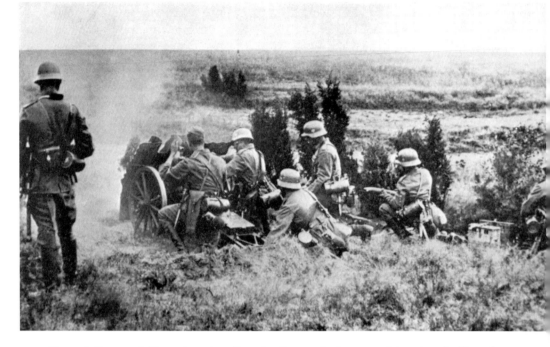

Above: A German field gun in action. On 1 April 1940, Paris reported that there had been heavy artillery fire in the area west of the River Saar, in the French/German borderlands.

Blitzkrieg!

'I have never used the word Blitzkrieg, because it is a very silly word.'
Adolf Hitler, November 1941.

Warfare prior to and including the First World War was dependent on horses, and the ideas of mobile warfare, beyond a guerilla campaign, were remote from the thoughts of military planners. Railways, being inflexible, could not be guaranteed beyond your own borders, and motor transport was rare and expensive, with its own logistical problems. The invention of the tank by the British during the First World War was the start of proper mechanised warfare, as opposed to the transport of men and weapons to the battlefield. The armoured tank provided a means of offensive warfare hitherto unknown. Little used by the Germans during the First World War, the tank became the major weapon of the campaigns early in the Second World War. The invasion of the Sudetenland area of Czechoslovakia in 1938 and the annexation of the remaining areas under Czech control in 1939 saw the giant Škoda works come under German control. This industrial combine made cars, lorries and tanks, as well as armour, and its acquisition helped mechanise the German army further. Škoda LT35 tanks helped provide the armour for the invasion of Poland in September 1939, with 244 being acquired with Czechoslovakia.

During the 1920s, increased mechanisation became a part of every army, with armoured scout cars, tanks, lorries and gun tractors being introduced. Despite this growth of vehicle use, the majority of soldiers were still reliant on horses and their own two feet to march to the battlefield. The First World War had also seen the advent of the fighting aircraft, whether bomber or fighter, and developments post-war included the beginning of dive-bombing and closer support between the air force and the army.

Germany itself had been starved into submission at the end of the First World War and war reparations had crippled the country economically in the immediate post-war period, with the effects of the Great Depression making things worse. In 1933, after a decade or more of campaigning, sometimes violent, and with their leader in jail for a period after the Munich Putsch, the Nazis came to power on a manifesto of making Germany great again. Thus began a campaign to create living space for the German race and a huge rearmament, including creation of the Luftwaffe and the invasion of some of the country's neighbours.

The Spanish Civil War gave the Nazis an opportunity to try out some of their new weapons and hone their tactics. It was there that they discovered the benefits of tactical bombing, of the quick movement of troops by air, and of using tanks

Below: In wooded country near to the Siegfried Line, this German machine-gunner is using a telescopic sight. The machine gun is manned by a team of three.

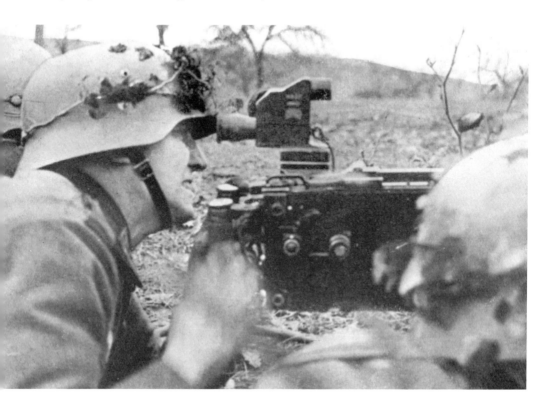

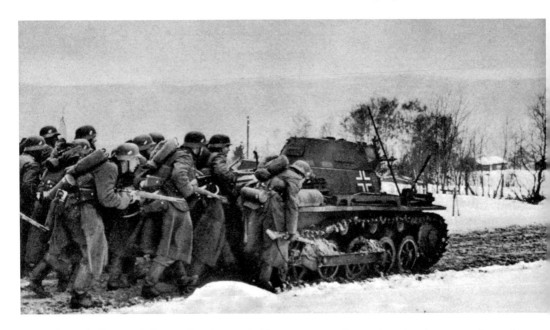

Above: A German infantry detachment in Norway moves forward under the cover of a tank.
Below: Burnt-out vehicles amid the ruins of a French town.

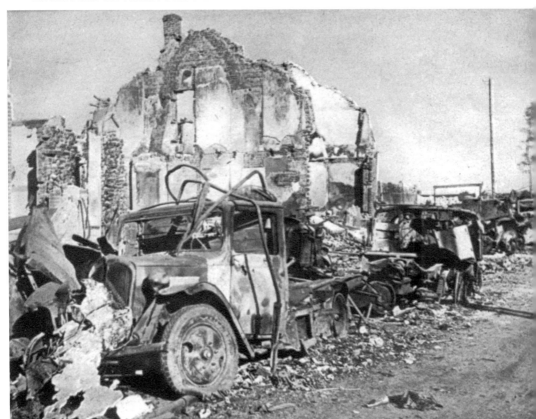

against less-well-armed opponents. Due in part to its financial state after the end of the First World War, and in part to the desire not to be bogged down in a war of attrition, the generals of the German High Command looked at the benefits of a quick war. During the mid-1930s, as countries either allied with the Nazis or succumbed to their yoke, it was obvious that Germany was not ready for a long war, and would not be until the mid-1940s. Both France and Germany had expended huge sums on defensive forts along their frontiers, with the West Wall (or Siegfried Line) protecting Germany's western frontier and the Maginot Line facing it. Of course, the French Maginot Line did not cover the border of France and Belgium, but the West Wall covered 670 km from Holland to Switzerland. Built between 1938 and 1940 it would help prevent an incursion by the Allies into Germany.

Blitzkrieg itself was, before Poland, an untested theory. However, it is safe to assume that it came about due to opportunities on the battlefield rather than as a considered plan. Elements of lightning war had been incorporated since the time of the Schlieffen Plan, namely the bypassing of major towns and ignoring pockets of the enemy, for them to be mopped up after they had been surrounded and bypassed. The Condor Legion in Spain had proved the abilities of many of Germany's new weapons, and had battle-hardened many of her troops. Some weapons and techniques had been shown to be outdated or old-fashioned but the principles of close support between Luftwaffe and Wehrmacht had been proven.

Below: On 14 May 1940, armoured forces gather at the Maas River crossing on the Belgian and French frontier. The towns of Dinant, Givet, Valenciennes and Abbeville fall in quick succession.

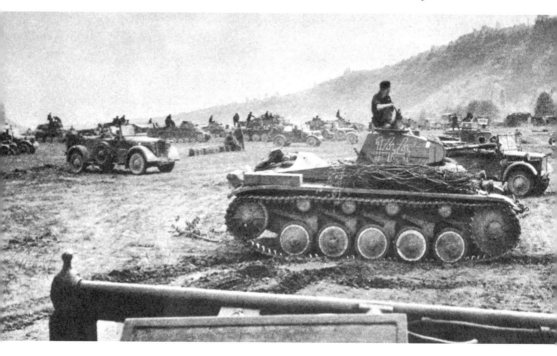

When Poland was invaded, it was the final straw for France and the United Kingdom, both of whom declared war on Germany. Soon a British Expeditionary Force was on French soil, as were squadrons of Hurricanes. For much of the early period of the war little of note happened on the border of France and Germany. The major battles of 1939 and early 1940 were at sea, from the sinking of the battleship *Graf Spee* to the loss of many ships to U-boats, and the period became known as the Phoney War, with preparations being made by both sides for the coming conflict.

With an imminent invasion of Norway by the United Kingdom, Germany's army took to the sea and invaded too in April 1940. After a short campaign, the British troops were soon withdrawn and Norway was under Nazi rule. In May, German armour and troops massed on the borders of France, Belgium, the Netherlands and Luxembourg, and a swift campaign saw the abandonment of France by Britain, with evacuations at Dunkirk, Cherbourg, Le Havre and St-Nazaire, as well as from smaller French harbours. In a ridiculous state of affairs, as hundreds of thousands of troops were being rescued from the flat beaches of Dunkirk, Allied troops were invading Brest and marching inland. They would soon be evacuated but thousands of soldiers of the BEF were captured. Paris fell and France capitulated, leaving Britain alone and facing a continent under the Fascist yoke.

Below: The human cost of war – the body of a French soldier lies where he fell.

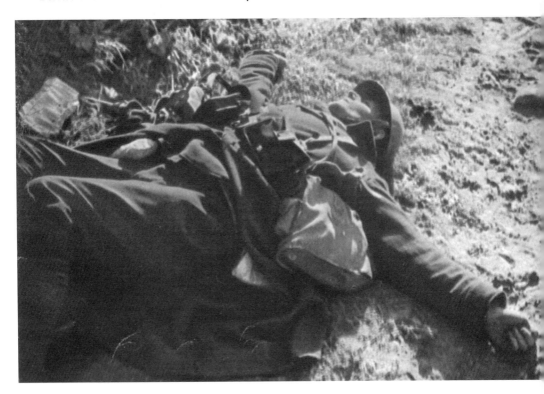

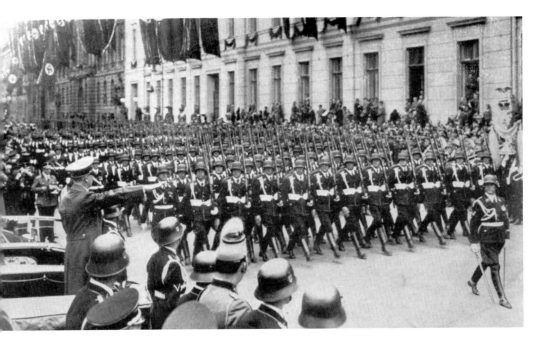

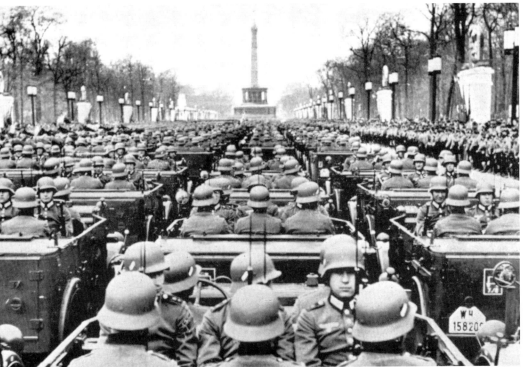

The scale of Germany's mechanised forces is revealed in this imposing show of strength held in Berlin to mark Adolf Hitler's fiftieth birthday on 20 April 1940. In the upper photograph the Führer is seen on the left, standing in his car to take the salute as his 'black guard' marches past. It is said that the parade lasted for a total of four hours.

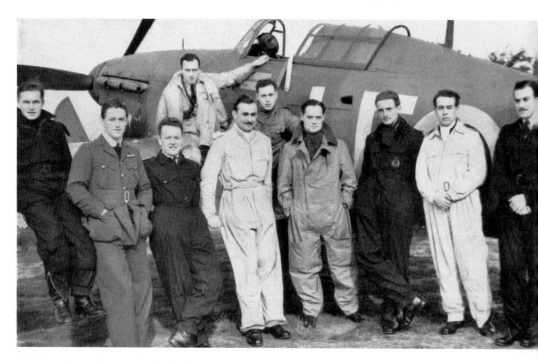

Squadron leader Douglas Bader returned to flying duties in 1939, and in the spring of 1940 took part in action during Dunkirk and the Battle of Britain. Bader had lost both legs in an earlier aircraft accident in 1931. He is shown here with members of his Canadian fighter squadron. Bader was credited with twenty aerial victories before being captured in 1941.

MAY 1940

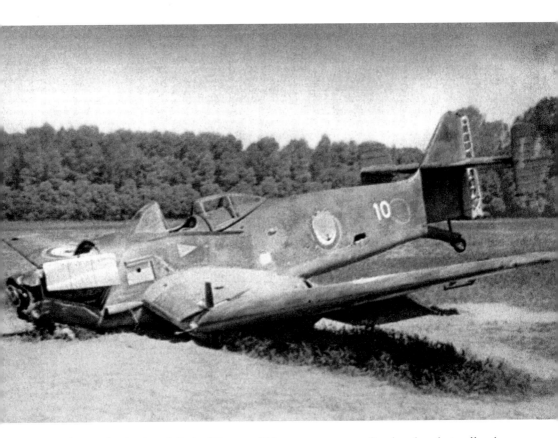

Above: The wreck of a French Loire-Nieuport LN401, a two-seater dive-bomber that suffered heavy losses in the Battle of France in the spring of 1940. The French air force ceased fighting in Europe on 25 June and the last remaining aircraft were withdrawn to northern Africa.

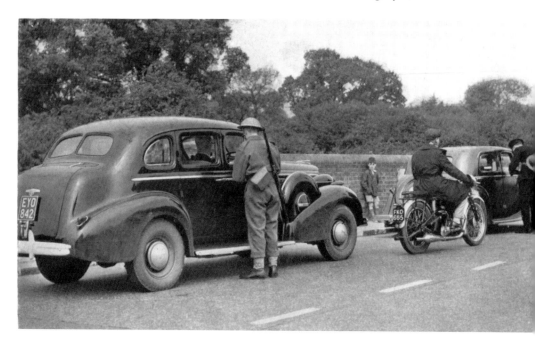

Above: Fearful that 'fifth column' agents were working in Britain, on 13 May troops and police cooperated in stopping motorists in order to check identification documents. A soldier and policeman are shown examining driving licences 'somewhere in England'. *Below:* Austrian and German men between the ages of sixteen and sixty are marched under armed guard to a train in a London station. They are being sent to an internment camp for the duration of the war.

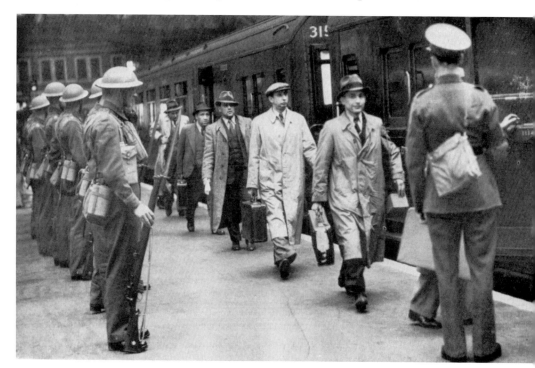

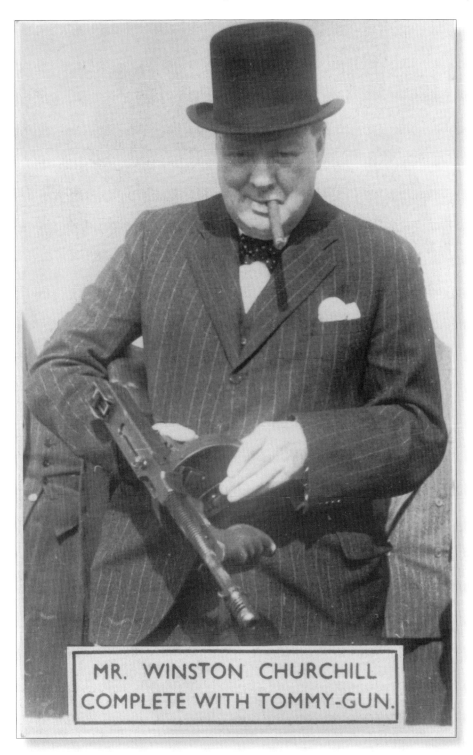

MR. WINSTON CHURCHILL
COMPLETE WITH TOMMY-GUN.

Above: With his cigar and pinstripe suit, Winston Churchill looks like a gangster holding a Tommy gun. The Thompson sub-machine gun was simple to use and cheap to mass-produce.

THE RT. HON. LORD LLOYD
Secretary for the Colonies.

THE RT. HON. N. CHAMBERLAIN
Lord President of the Council.

THE RT. HON. VISCOUNT HALIFAX
Foreign Secretary.

THE RT. HON. A. EDEN
Secretary of State for War

THE RT. HON. A. V. ALEXANDER
First Lord of the Admiralty.

THE RT. HON. WINSTON CHURCHILL
Who succeeds Mr. Neville Chamberlain as Prime Minister, and
also becomes Minister of Defence. Mr. Churchill accepted
the Premiership and undertook to form a new ministry on 10th May.

THE RT. HON. E. BEVIN
Minister of Labour.

THE RT. HON. A. DUFF COOPER
Minister of Information.

THE RT. HON. SIR A. SINCLAIR
Secretary of State for Air.

THE RT. HON. LORD WOOLTON
Minister of Food.

THE RT. HON. VISCOUNT CALDECOTE
Secretary for the Dominions.

THE RT. HON. SIR J. SIMON
Lord Chancellor.

THE RT. HON. L. C. S. AMERY
Secretary for India and Burma.

On 10 May Winston Churchill became Prime Minister of an all-party coalition government.

THE RT. HON. E. BROWN
Secretary for Scotland.

THE RT. HON. SIR J. ANDERSON
Home Secretary.

THE RT. HON. LORD HANKEY
Chancellor of Duchy of Lancaster

THE RT. HON. SIR A. DUNCAN
President of Board of Trade.

THE RT. HON. R. S. HUDSON
Minister of Agriculture.

THE RT. HON. C. R. ATTLEE
Lord Privy Seal and Deputy-Leader of House of Commons.

THE RT. HON. SIR K. WOOD
Chancellor of the Exchequer.

THE RT. HON. M. MACDONALD
Minister of Health.

THE RT. HON. H. MORRISON
Minister of Supply.

THE RT. HON. A. GREENWOOD
Minister without Portfolio.

THE RT. HON. HUGH DALTON
Minister of Economic Warfare.

THE RT. HON. RONALD CROSS
Minister of Shipping.

THE RT. HON. SIR J. REITH
Minister of Transport.

THE RT. HON. LORD BEAVERBROOK
Minister of Aircraft Production.

THE RT. HON. H. RAMSBOTHAM
President of Board of Education.

Including Churchill himself, the new Cabinet included four past and future prime ministers.

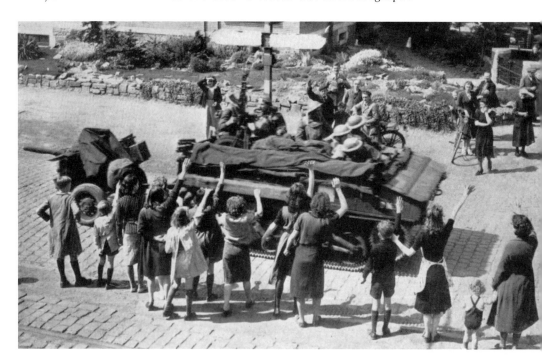

Above: Inhabitants of a Belgian town welcome British transports taking the men of the BEF on their way to the battlefront. Note the Bren gun pointed upwards to deal with attacks by enemy aircraft. *Below:* British troops man a machine-gun post at a street corner in Belgium. They are surrounded by the damage to buildings caused by recent air raids.

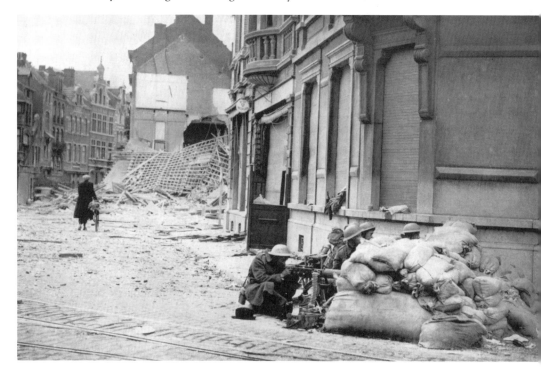

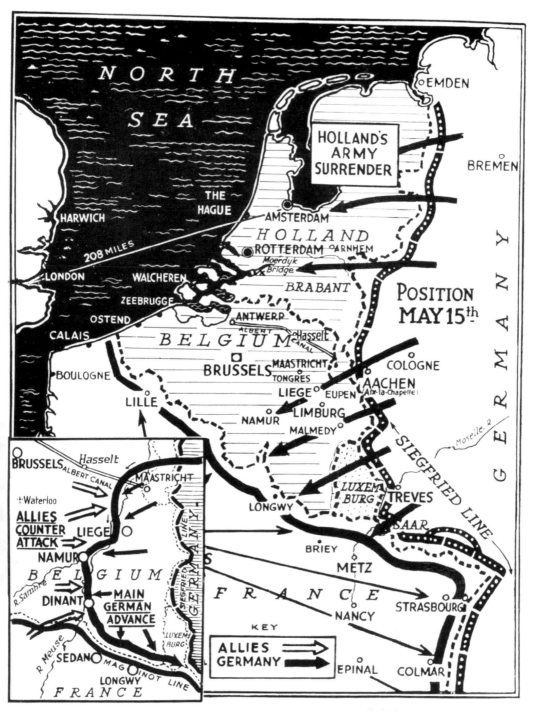

Map showing the extent of the German push into Holland, Belgium and Luxembourg on
15 May 1940. The main attack had extended from Liège, on the Meuse, to Longwy, west of
Luxembourg. The inset map shows the Allies' counter-attack from the left bank of the Albert
Canal to the right bank of the Meuse below Dinant.

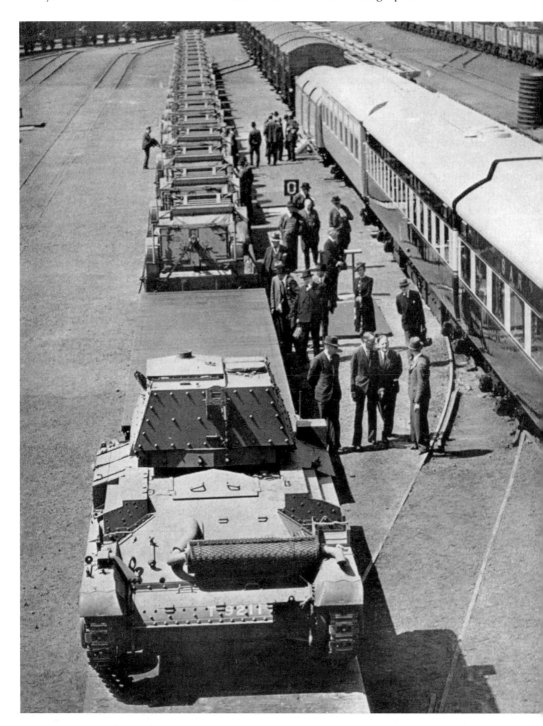

Above: A special train loaded with a single tank plus a number of artillery limbers is readied for the journey to the Channel, where its cargo will be transferred to a ship for delivery to the BEF. Moving military supplies, together with the transportation of troops, was one of the main duties of the railways during this period of building up the army's resources in France and Holland.

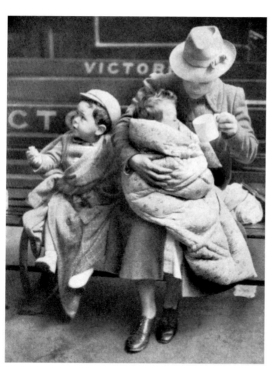

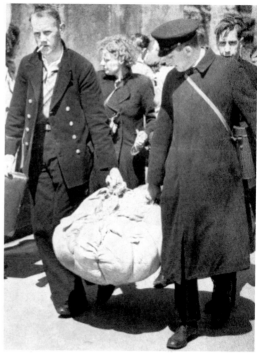

Thousands of refugees poured across the Channel into England. *Above:* A mother and her two children were among a party newly arrived at Victoria station in London, and Dutch men and women are shown carrying their bundles of belongings. *Below:* Dutch refugees line up at Liverpool Street station after two sleepless nights in the hold of their ship.

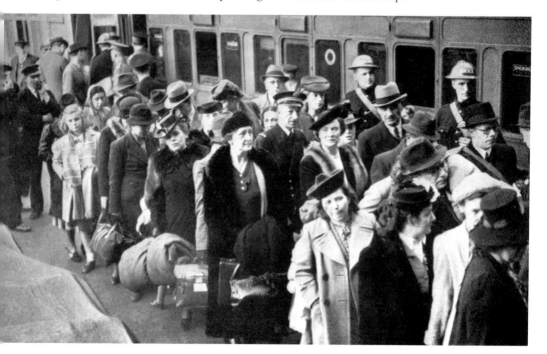

Above: A British anti-tank post in the ruins of the university city of Louvain. On 17 May a British communiqué stated that attacks on the city had been repulsed, but it was to be short-lived.

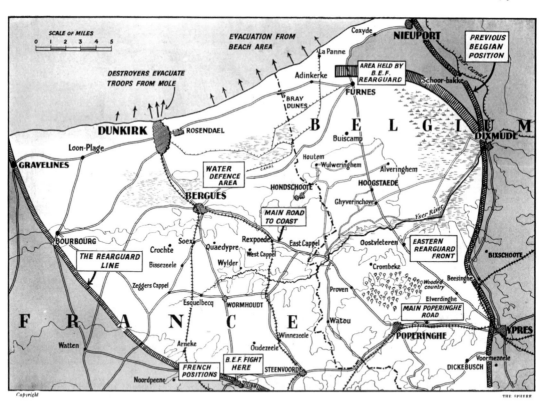

Above: The location of rearguard action, and the area of evacuation from the beaches. *Below:* British and French troops trudge through a street in Dunkirk, littered with debris.

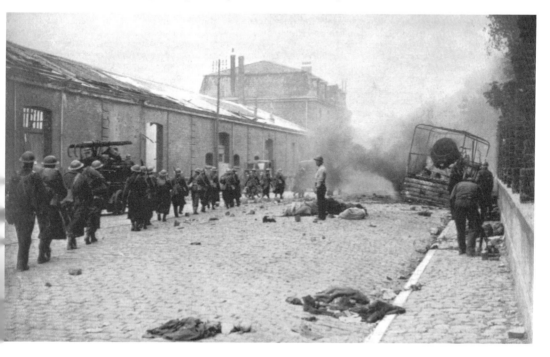

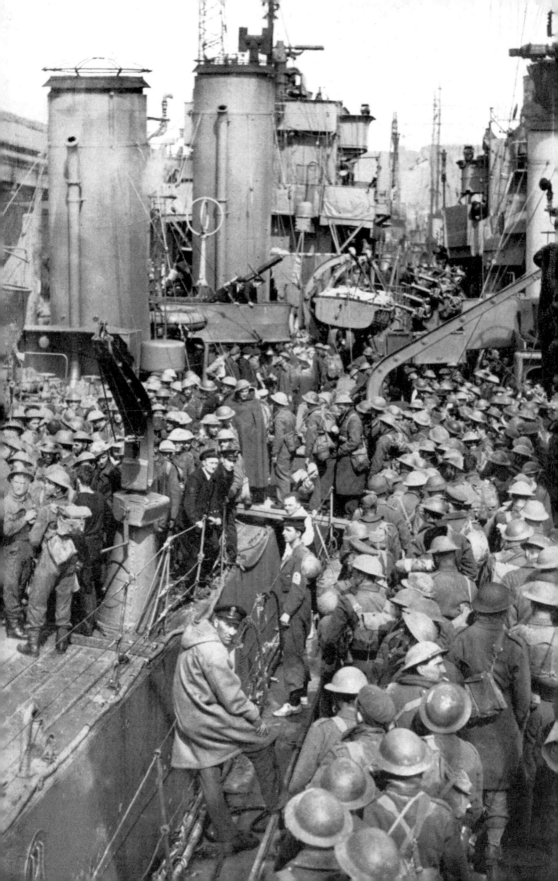

JUNE 1940

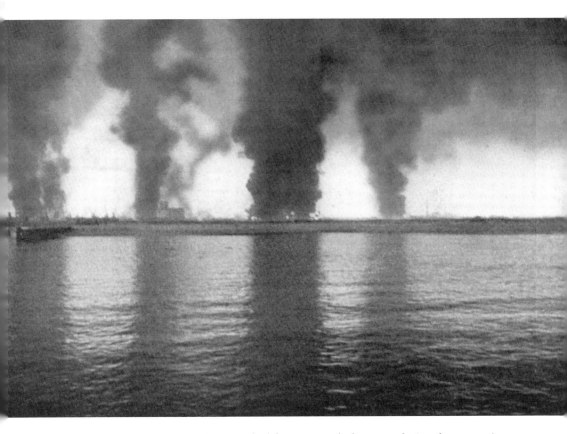

Above: Fires rage in Dunkirk as photographed from a British destroyer during the evacuation. Despite heavy attacks by the enemy from land and air, Operation Dynamo saw the withdrawal of four-fifths of the BEF against tremendous odds.

Opposite page: Royal Navy destroyers with their decks packed with troops on arrival at a British port following the 'miracle of deliverance', as Churchill described it.

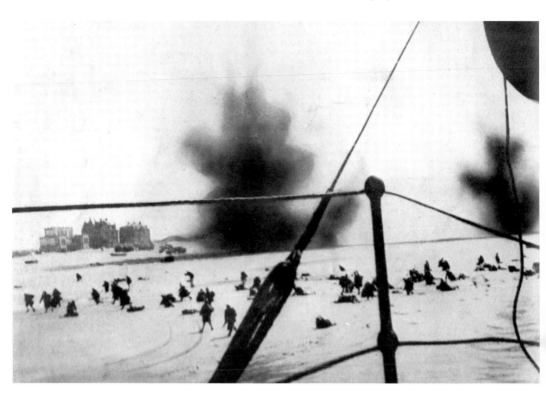

As bombs rained upon the beach at Dunkirk, the Allied troops took what cover they could find on the unprotected sands before wading or swimming to the flotilla of rescue vessels.

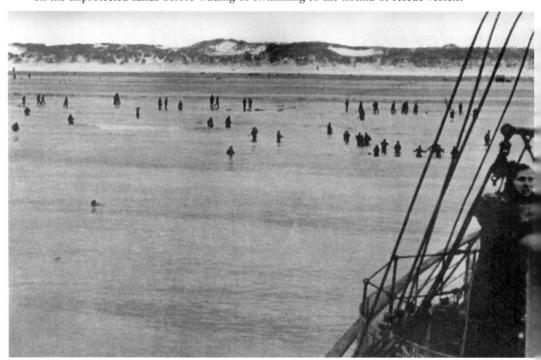

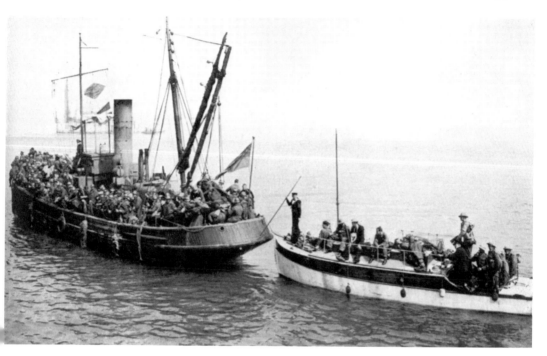

Operation Dynamo was completed on 4 June. *Above:* A tug together with a small motorlaunch in tow, laden with the troops evacuated from Dunkirk. *Below:* All forms of little vessels had answered the call. Among them were hundreds of motorlaunches, fishing smacks, coastal freighters and all sorts of pleasure craft. Over 338,000 men were saved, but scores of ships had been lost, including seven French destroyers that were sunk.

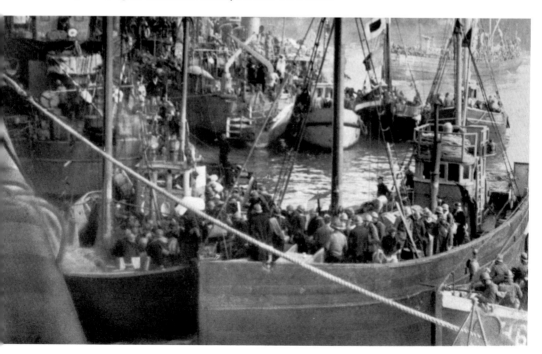

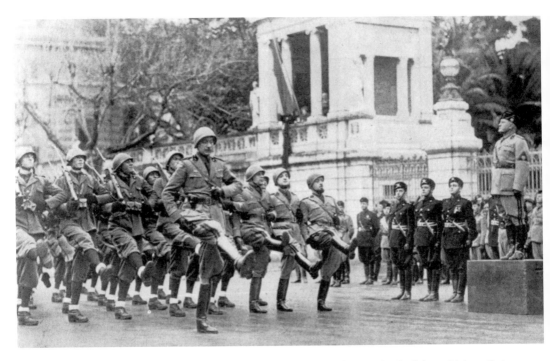

On 10 June, Italy's Benito Mussolini declared war on the Allies. Hitler had forced Mussolini to hold back his declaration until the defeat of the French air force was complete. Neither would the Duce be allowed a share of the glory in any armistice talks with the French.

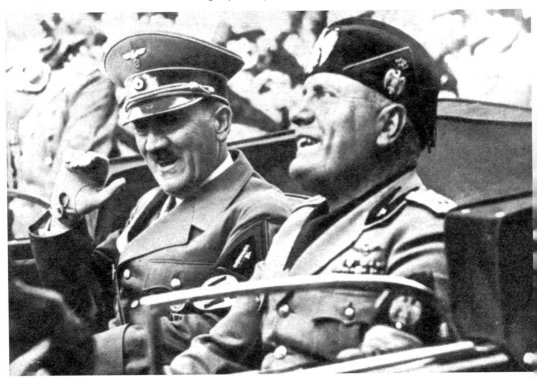

Above: As the Battle of France reaches its climax, a column of German troops are seen continuing their advance with Paris firmly in their sights.

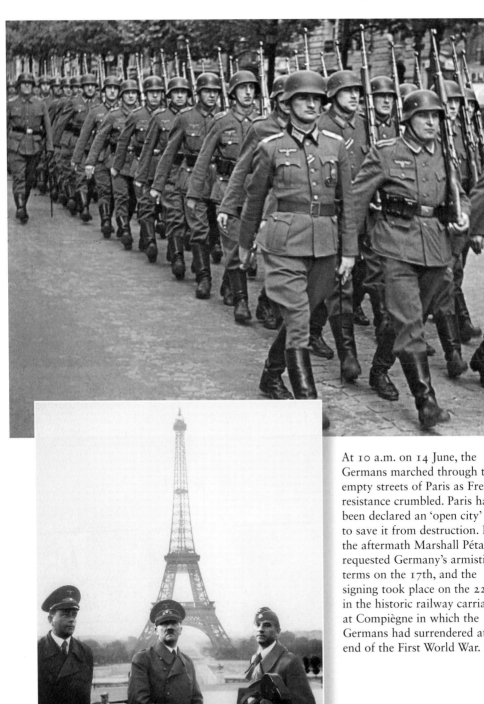

At 10 a.m. on 14 June, the Germans marched through the empty streets of Paris as French resistance crumbled. Paris had been declared an 'open city' to save it from destruction. In the aftermath Marshall Pétain requested Germany's armistice terms on the 17th, and the signing took place on the 22nd in the historic railway carriage at Compiègne in which the Germans had surrendered at the end of the First World War.

Left: France had fallen and Hitler takes in the sights of Paris, posing for the photographers in front of the Eiffel Tower.

The sinking of the *Lancastria*

'Roll out the Barrel', the troops sang as they clung to the upturned hull of the sinking liner. Despite the ship carrying upwards of 6,000 troops, men, women and children, over 3,500 of whom died as she foundered, the British people did not learn of her loss for six weeks after she had gone to a watery grave. It was just the latest in a long line of cover-ups by the British government, intent on keeping the desperate situation in Europe from the people at home. After the 'Miracle of Dunkirk', it was felt that bad news would be more than the British public could take.

On 4 June 1940, the last of 338,226 British, Commonwealth, Polish, French and Belgian troops boarded British destroyers at Dunkirk. The British Expeditionary Force had been saved, or so Winston Churchill led the nation to believe. However, around 200,000 British troops still remained in France, and many soldiers of other nationalities were trapped too. All were heading westwards, with units of the 51st Highland Brigade making a valiant effort to escape from St-Valéry-en-Caux. Evacuation would never come for these men, and by 12 June, over 10,000 British troops and many more French had surrendered to General Erwin Rommel. For over 130,000 more British troops, hope lay in the west and they trudged onwards to Brittany and the ports of St-Nazaire and Brest. It would be their last hope of escape from the clutches of the Nazis.

At the port of St-Nazaire, evacuating troops and refugees, were the Cunard White Star liner SS *Lancastria*, the Orient Line's *Oronsay*, the SS *John Holt* and numerous other ships, including the destroyers HMS *Havelock* and *Highlander*. The ship of

Below: The Cunard White Star liner SS *Lancastria* leaving Lerwick in July 1937.

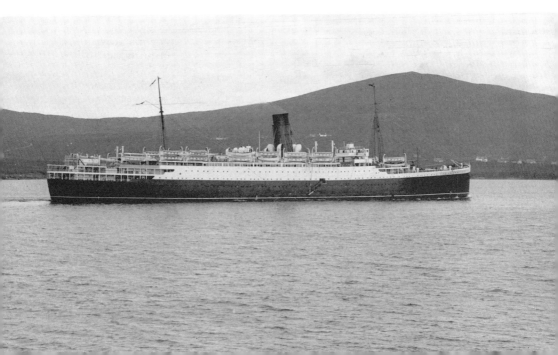

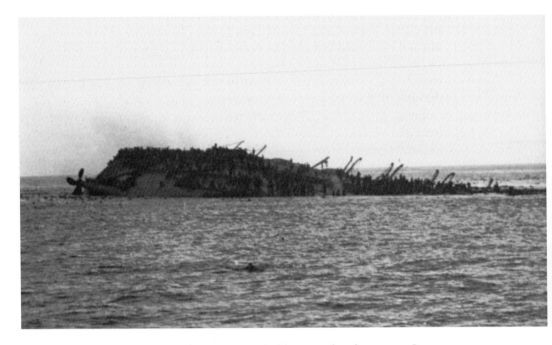

Above: Lancastria sinking after being attacked by Ju 88 bombers on 17 June 1940.

our story, the SS *Lancastria*, had been one of Cunard's luxurious cruise ships, so how did she come to be in a French port, boarding thousands of people desperate to escape the panzers that were trundling across France intent on preventing the escape of these men, women and children?

The *Lancastria* was built as Anchor Line's *Tyrrhenia* by William Beardmore's yard at Dalmuir, and entered service in 1922. Destined for the line's Canadian service, she was 16,243 grt and 552 feet 8 inches long and could carry 235 in first class, 355 in second and 1,256 passengers in third class. With 300 crew, she made her maiden voyage from Glasgow to Quebec and Montreal on 13 June 1922, thereafter operating on the Liverpool–Quebec–Montreal service. Earning the nickname the 'Soup Tureen' she was renamed in 1924 as *Lancastria* and transferred to the London–Le Havre–Southampton–New York route in 1926. A decade later, painted white, she began cruising, both from Britain and America, soon gaining a reputation as a luxury vessel, suited to the demands of the rich Americans who flocked to her.

When war was declared, she was on a cruise to the Bahamas and set sail from Nassau back to New York, where work began to fit her out as a troopship. No longer would she have the trappings of a millionaires' ship, but her interiors would be stripped out or covered up, and the cabins and any available space filled with bunk beds, her crew serving two meals a day to the thousands of troops she would carry from Canada rather than the three meals, afternoon tea and numerous other snacks to a more fortunate clientele. Part of a fleet of liners used to evacuate troops from Norway, she survived an attack by German bombers. Once she had deposited the war-weary troops in Scotland, she sailed for Iceland with soldiers to garrison the

island. With only a 4-inch gun to protect her, she returned to Glasgow before sailing for Liverpool and a badly needed rest for the crew and a refit for the ship. It was 14 June 1940, ten days after Dunkirk.

That afternoon, the crew was recalled; the ship was sailing at midnight. It was too late to empty the tanks of fuel oil, as had been requested at Glasgow. The *Lancastria* was to sail as soon as she could for Plymouth and a future destination unknown. The military situation in France was desperate, and so was the political one – France was ready to capitulate and British troops needed rescuing to continue the fight against the Germans. As the *Lancastria* was readied for what was to be her final voyage, Paris was being occupied. The public were kept in the dark about the tens of thousands of troops still trapped in France, a situation that continues to this day, much like the story of the *Lancastria*'s last days. It was *Lancastria*'s job to rescue as many as she could of these missing men. Despite the evacuation at Dunkirk, a whole Canadian division left Britain for Brest. They would add to the men already there, men who had to all intents and purposes been forgotten, and left to make their way to ports where they may have been able to escape. Many headed for St-Nazaire and Nantes, both of which had been in use since the start of the war to bring men and material into France for the British Expeditionary Force.

On the morning of 15 June, the notice was given to evacuate St-Nazaire within the day. *Lancastria*'s deck officers noticed the numerous other ships also sailing for Plymouth and knew something big was in the offing. Ships were sailing for Brest, as well as to Cherbourg and St-Malo to evacuate the troops there; meanwhile, *Lancastria* awaited orders at Plymouth. Operation Arial was to rescue another 186,700 troops, an amazing number and one we rarely hear about. The Canadians who had landed at Brest had turned round and, without firing a shot, were evacuated with the loss of six men, who had gone missing en route. There were still 50,000 men in France, centred around the mouth of the Loire. Now it was their turn to be evacuated in the biggest rout in British military history.

Lancastria was ordered to Brest, in company with the *Franconia*, but the Germans had laid magnetic mines there and she sailed down the coast towards St-Nazaire. *Franconia* suffered a near miss and limped back to Liverpool. Joined by a fleet of seven ships, led by the SS *John Holt*, *Lancastria* sailed south. Meanwhile, the troops she was to rescue began to systematically destroy the material and equipment that they could not return to Britain. Troopships began to collect in the bay of Quiberon on 16 June, including the White Star's *Georgic*, Canadian Pacific's *Duchess of York* and the Polish vessels *Sobieski* and *Batory*. Small boats took troops out to the near defenceless merchantmen, and the evacuation began in yet another French port.

The RAF had been evacuated to the Channel Islands and the Luftwaffe ruled the skies of France. The dive-bombers attacked with impunity and, as the tanks sped across western France, evacuation continued. By midnight on the 16th, 17,000 had been rescued. As well as the soldiers, there were civilians, including Salvation Army members, workers from the Fairey aircraft factory at Charleroi, Belgium, complete with plans and tools of military aircraft. *Lancastria* entered Quiberon Bay on the morning of 17 June, her job, to rescue as many men as possible. She was capable of

taking 3,000 men, but that day many more would board her. The destroyers *Havelock* and *Highlander* regularly entered the port, bringing troops back to *Lancastria*, 4 miles out, along with tugs, fishing boats and other small ships. While the small ships sailed between St-Nazaire and the troopships waiting to be filled, Rommel made a 150-mile dash to take Cherbourg and the war took another turn for the worse for Britain. The country needed good news and this was not the day for it. As *Lancastria* filled, the troops took in their new surroundings. Some went to the bars, others took baths, their first for weeks, while the unlucky were crammed below in every nook and cranny that could accommodate them. Over 800 RAF personnel filled a dark hold; some men decided to take the risk of being shot at and remained on deck.

The stewards, who had been counting their passengers as they boarded, stopped at 6,000. Hundreds, if not thousands, more piled aboard the 16,000-ton ship. We will never know just how many she took aboard, but with a low estimate of 6,000 and a high estimate of 9,000, she was a juicy target for the Luftwaffe's dive-bombers. By mid-afternoon, the sea doors were closed and *Lancastria* refused more passengers. Those who came headed for the *Oronsay*, the other large ship in the bay. *Lancastria* was ready to sail, overloaded, and deep in the water, and was given orders to go. Watching an attack on *Oronsay* in which a bomb hit the Orient Liner's bridge, killing several and destroying the chartroom, steering and wireless rooms, *Lancastria*'s captain, Rudolph Sharp, ignored the order, hoping for a naval escort. It was a fatal mistake and one that was to cost the lives of at least 3,500.

The *Oronsay*, with her two funnels, was the choicer target for the Luftwaffe pilots, and *Lancastria* stayed in the bay as attack after attack rained down on *Oronsay*. At 3.44 p.m., *Lancastria* was under attack, the first bombs missing her. Six Ju 88s circled the liner, ready to attack her. It is thought that the Junkers of Peter Stahl dropped a stack of bombs, four hitting *Lancastria*, three directly into the holds, killing hundreds, including most of the 800 RAF men in one hold. The fourth bomb hit close to the funnel, or may even have dropped down it. It was this bomb that would be the decisive blow. Fatally wounded, her bulkheads cracked, an oil tank ruptured, steam pipes burst, and thousands dead or wounded as a direct result of the bombs, she began to settle in the water. Some troops jumped overboard as she began to list, others tried to escape from below decks, quickly becoming disorientated as she listed to one side, trying to crawl over the mangled wreckage and crushed and broken bodies.

Burned by steam, hit by shrapnel, covered in oil and blood, they tried desperately to escape from below decks. Those who had jumped into the water or had managed to launch a lifeboat faced another hell. The Germans were machine-gunning them, killing and injuring many defenceless survivors. Soon, the list on *Lancastria* was unrecoverable, and she started to roll onto her side, men clinging to the hull, trying to keep their balance as she shifted, singing 'Roll out the Barrel'. It was barely 4.10 and the stern started to rise in the water as *Lancastria* made her final journey. One German plane was shot down by a Hurricane, but the others continued to strafe the victims. At 4.12 p.m., *Lancastria* had gone, leaving a pool of oil, and thousands of men and bodies in the water. *Highflyer* continued to fire at the German planes, while

the job of rescue began. French fishing boats joined the evacuation fleet in rescuing as many men as possible. The *John Holt* took on 1,100, and men were still being pulled out of the water after 9 p.m, a full five hours after the ship sank.

Bodies began to be washed ashore, and a local woman donated a field for the purpose of burying the victims. Many remained in their watery tomb though. Over 23,000 men escaped from St-Nazaire that night, many thankful to be among the 2,500 saved from *Lancastria*. It is unknown how many actually died. The simple fact was that no one kept a record of those on board and that in the best case scenario more men, women and children died than in the peacetime disasters of the *Titanic* and *Empress of Ireland*, plus the wartime torpedoing of the *Lusitania* combined. The British newspapers did not report the loss for a full six weeks. Like the story of Operation Ariel, little is known today of Britain's worst maritime disaster, despite the best efforts of the *Lancastria* Association, and attempts to provide a medal for those who survived have been ignored by the British government. Whatever the death toll – 3,000, 4,000, 5,000 – the victims of the *Lancastria* deserve to be better known. For details of the HMT *Lancastria* Association, visit their website at www.lancastria.org.uk.

Below: Survivors of the *Lancastria* crowded on a a rescue ship. Around 2,500 were saved, but estimates of the death toll vary as no record was made of those who had boarded the ship.

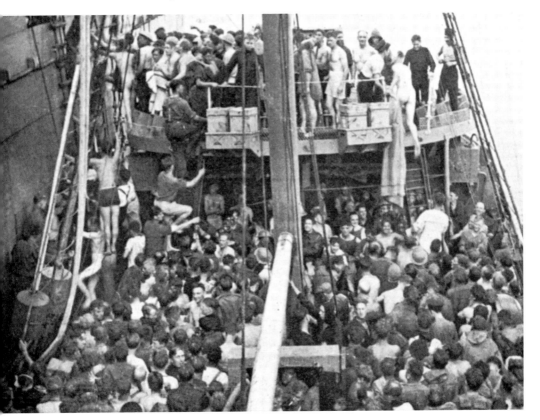

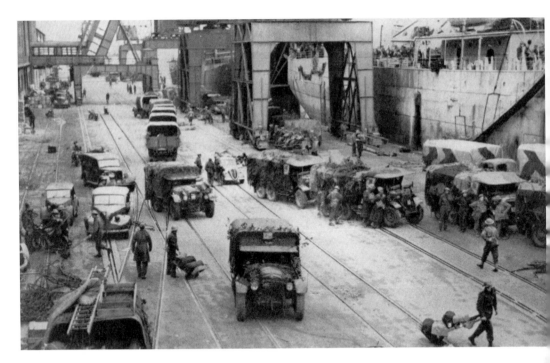

The evacuation of the remaining Allied forces from France, from 15–25 June, was a more orderley affair than Dunkirk, apart from the loss of life in the sinking of the *Lancastria*. *Above:* Lorries at the dockside in Cherbourg. *Below:* With their decks filled to overflowing the ships bring the remainder of the BEF home.

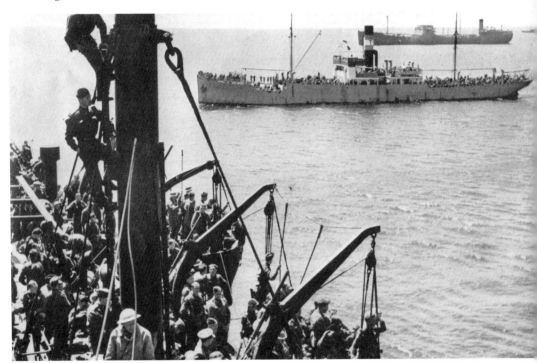

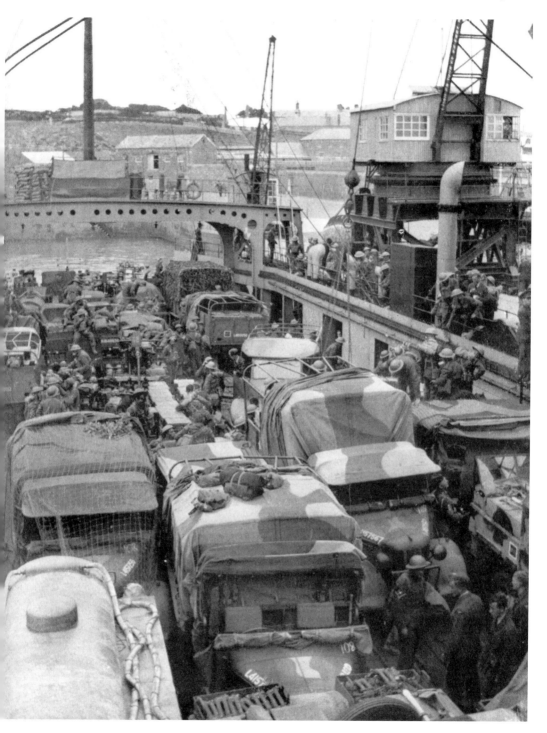

Above: The scene at the French port of St-Malo during the second evacuation of Allied forces. Unlike at Dunkirk, this time the greater part of the equipment and supplies was also retrieved. Now it was time to defend Britain itself.

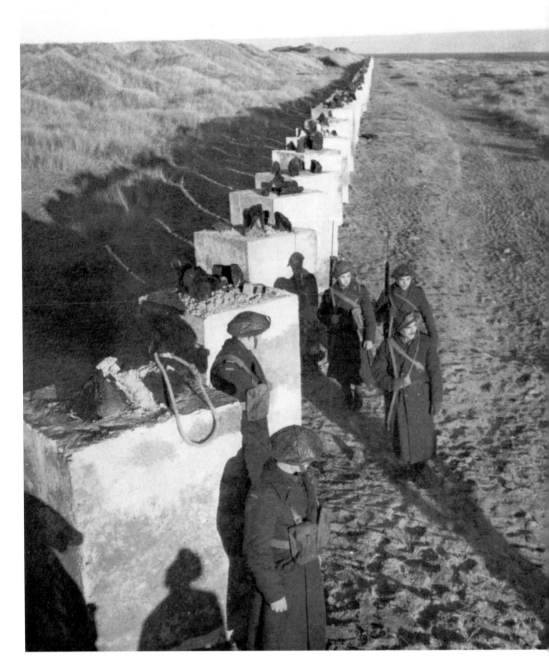

Above: Coastal defences in the form of concrete blocks protecting the British shoreline from an armoured landing. This is the scene on the Scottish east coast where Polish soldiers stand guard in case of a northern invasion.

JULY 1940

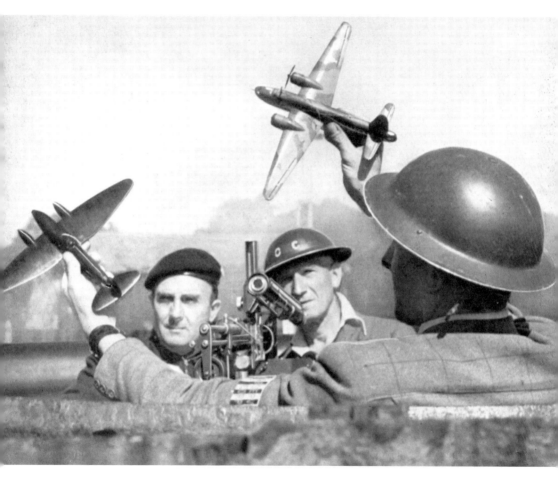

Above: More than just play-acting, members of the Observer Corps are trained to recognise aircraft at a glance through constant practice. The instructor is showing them scale models of a Spitfire and a Wellington.

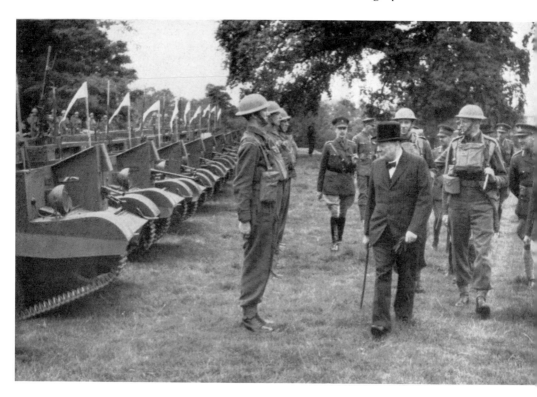

As Britain prepares for the expected Nazi invasion, the Prime Minister, Winston Churchill, takes a personal interest in the nation's defences. *Above:* Inspecting Grenadier Guards lined up in front of their Bren-gun Carriers. *Below:* Visiting men of the Cambridgeshire Regiment stationed on the East Coast, and examining the construction of coastal defences.

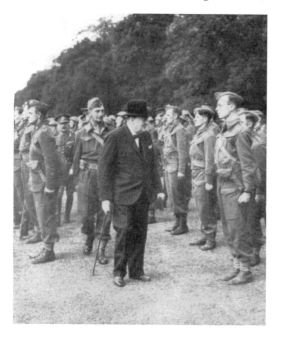

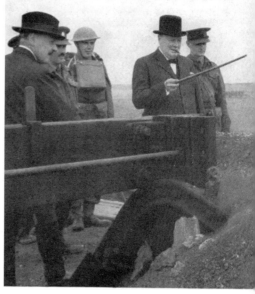

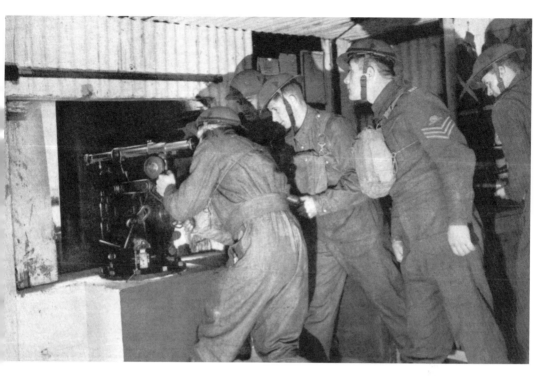

Above: The interior of the many pillboxes that were scattered along the coast and about the country. The gun crew is at work within the cramped conditions. *Below:* Here they are shown in a sandbagged emplacement built in the form of an annexe to one of the pillboxes. A Lewis gun crew is on guard against enemy air attacks.

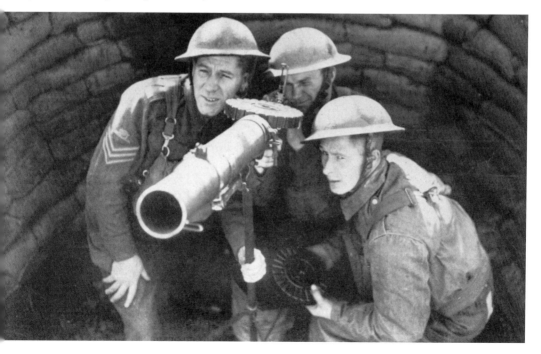

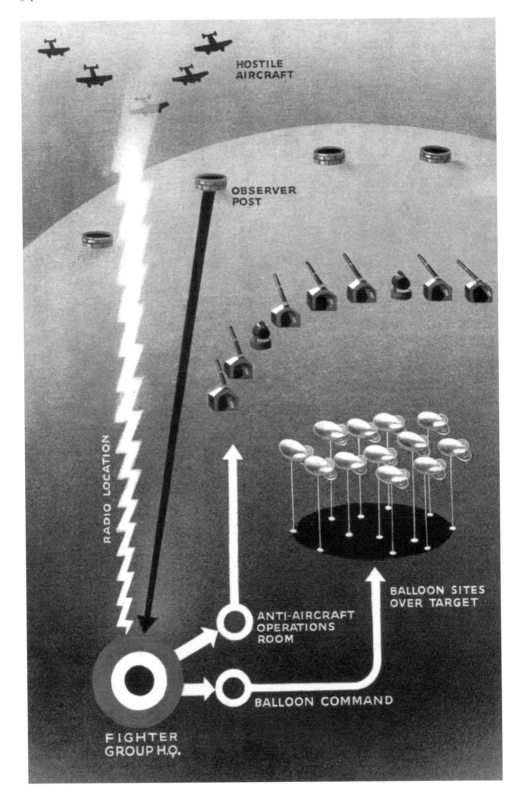

HOSTILE
AIRCRAFT

OBSERVER
POST

RADIO LOCATION

BALLOON SITES
OVER TARGET

ANTI-AIRCRAFT
OPERATIONS
ROOM

BALLOON COMMAND

FIGHTER
GROUP H.Q.

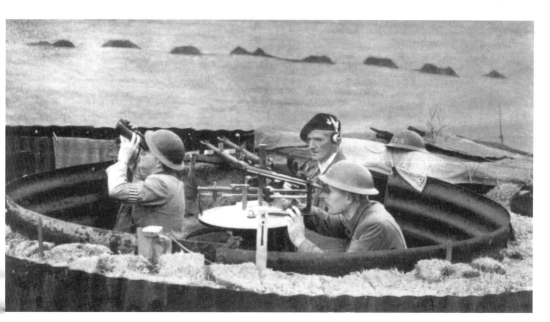

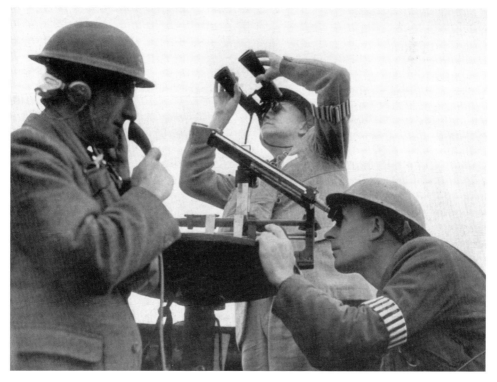

As shown opposite, the observer posts were at the very front of Britain's defences against air attack, and their information was passed directly to Fighter Group HQ. *Above:* Members of the Observer Corps at a remote post. The men were all volunteers and their motto was, 'Forewarned is forearmed'. One man is using a theodolite device to establish an aircraft's height and location, while another scours the sky with binoculars, and the third conveys reports by telephone.

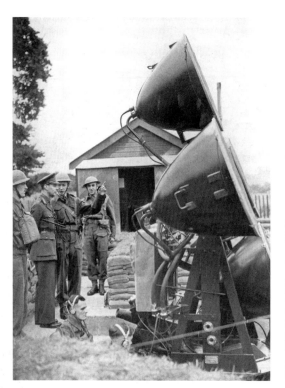 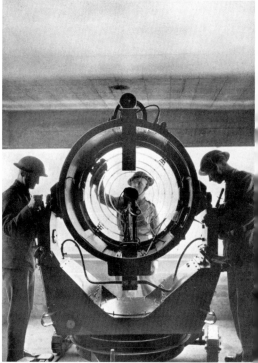

Above left: The King is on the East Coast to see the sound location equipment, similar to that used in the First World War, that backs up the visual sightings. It was especially useful during the hours of darkness, and the information was relayed to the searchlight units and the anti-aircraft gun batteries. A typical battery is shown below.

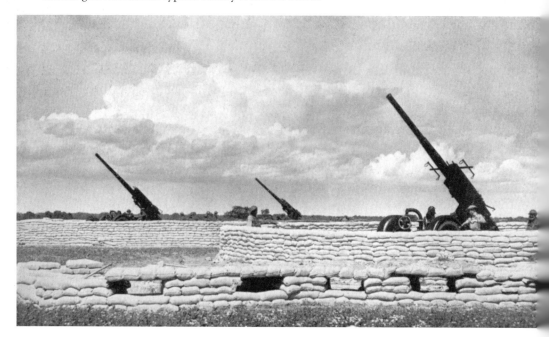

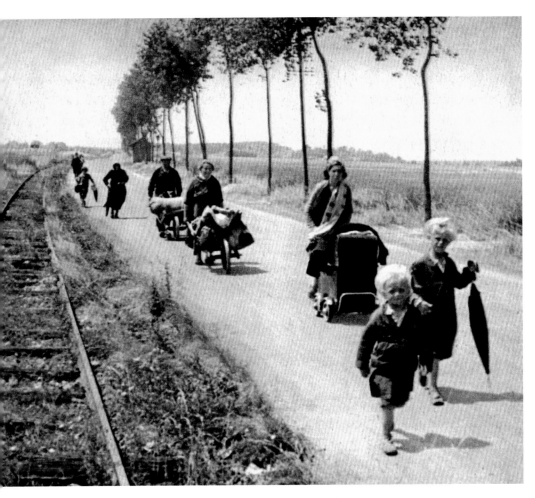

Above: The human cost of war. These French civilians flee from the invading Germans forces, using wheelbarrows, prams and bags to carry their possessions.

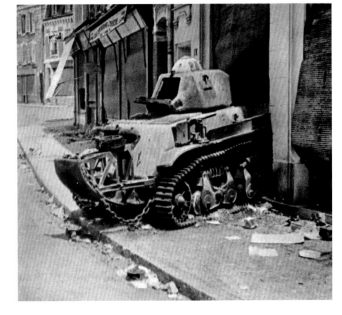

Right: The French tanks were no match for the German panzers, artillery and anti-tank guns. This damaged tank has been abandoned in a deserted street.

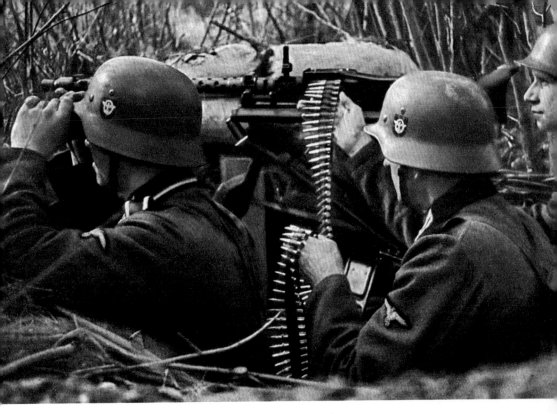

Above: A German three-man machine-gun team. The MG 34 was carried by one man, another fed the ammunition while the third spotted targets. *Below:* Radio communication played an important role in coordinating the rapid movement of troops, armour and airborne forces.

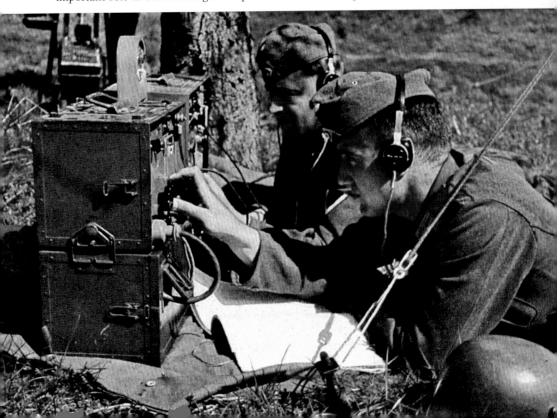

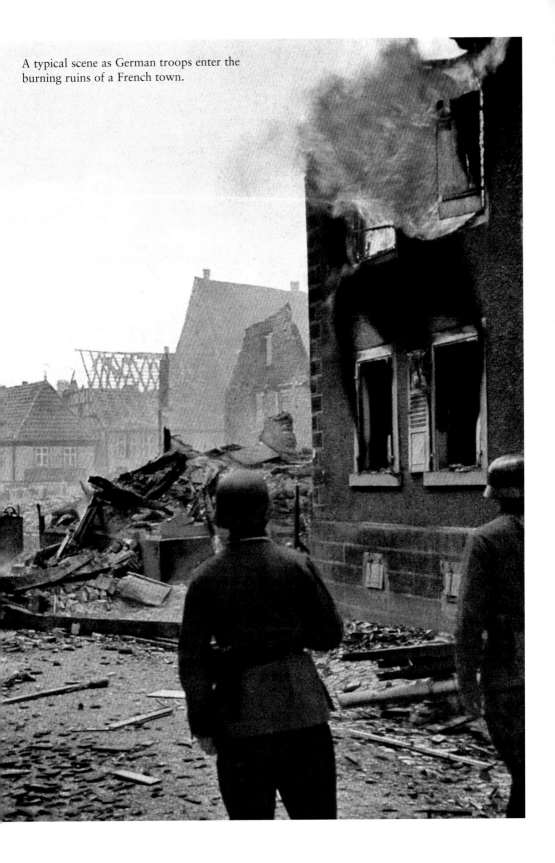

A typical scene as German troops enter the burning ruins of a French town.

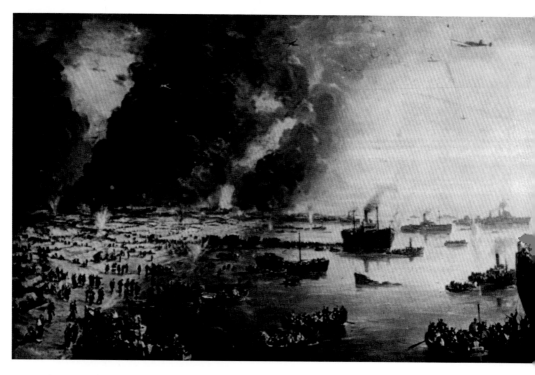

Above: Withdrawal from Dunkirk took place from 26 May to 2 June 1940. In this painting by Charles Cundall, palls of black smoke rise above the flat sands as the troops wade out to a flotilla of little boats. *Below:* The Germans entered Paris on 14 June. These exhausted soldiers ride into the city on the back of a gun limber.

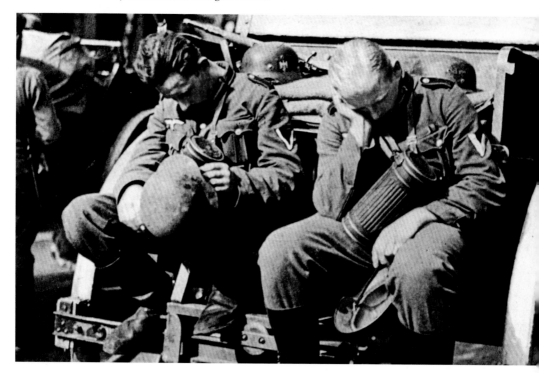

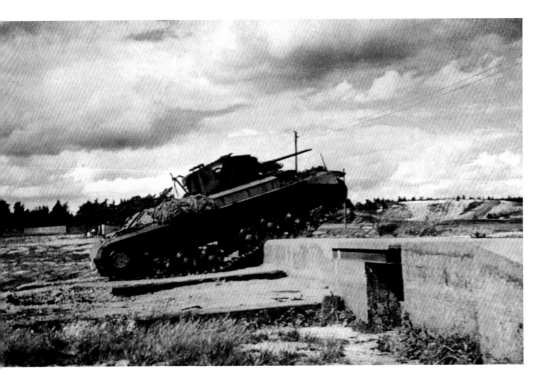

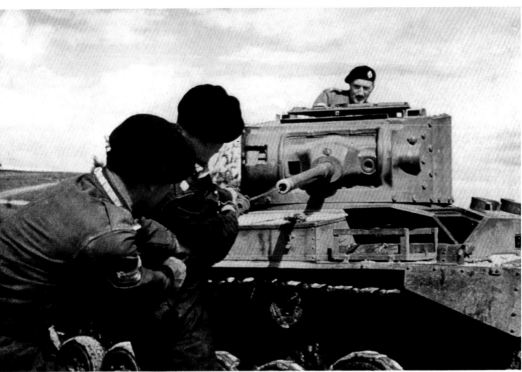

Above: A British Valentine tank being put through its paces prior to shipment to the Middle East. In the lower photograph the barrel of the 2-pdr gun is being cleaned.

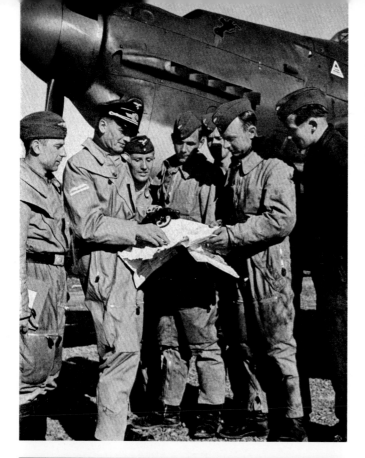

Left: Stuka crews study the charts during a pre-mission briefing. The Junkers Ju 87 dive-bomber had made its combat debut in the Spanish Civil War and was used to devastating effect in the Blitzkrieg, its wailing 'Jericho-Trompete' sirens striking terror in its intended victims.

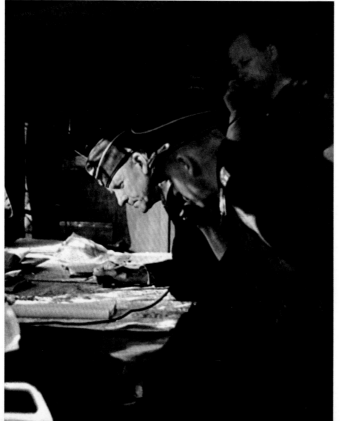

Left: Officers in a mobile Luftwaffe command centre coordinate an air strike.

Opposite page: The engine covers are removed as this Heinkel He 111 is readied for a bombing mission. The lower photograph shows the the 'Beobachter', or observer, checking the aircraft's position. He is inside the glazed nose section of the Heinkel.

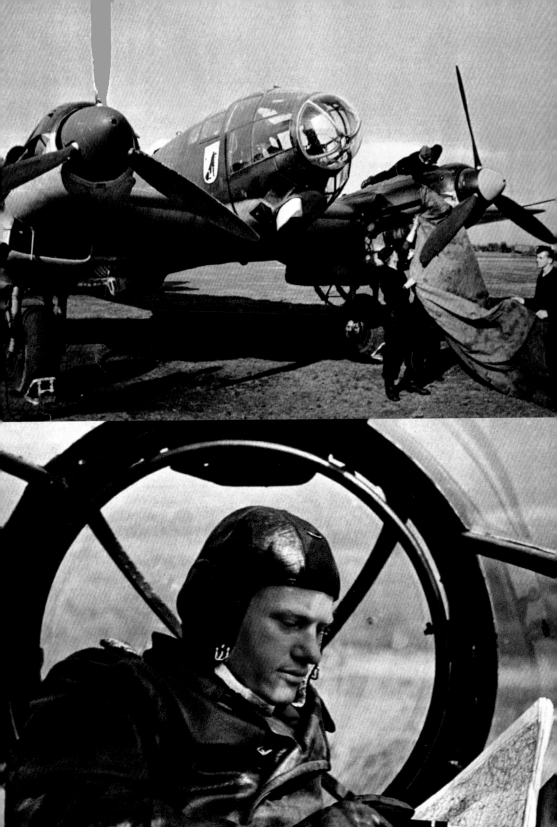

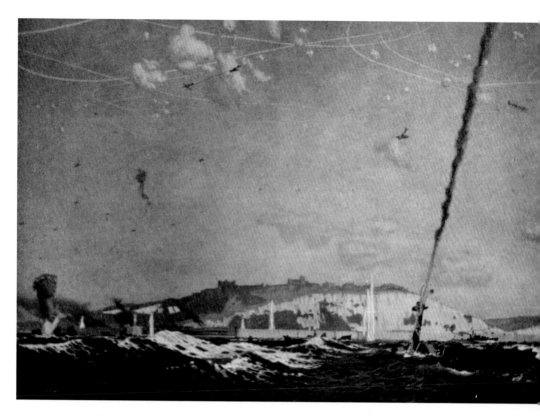

Above: 'Off Dover, 1940', a painting by war artist Charles Piers. The sky is criss-crossed by vapour trails left by defenders and attackers alike amid the shellfire and barrage balloons. *Below:* In this German propaganda photograph a Messerschmitt Bf 110 is flying alongside the white cliffs, a potent symbol of Britain's island fortress.

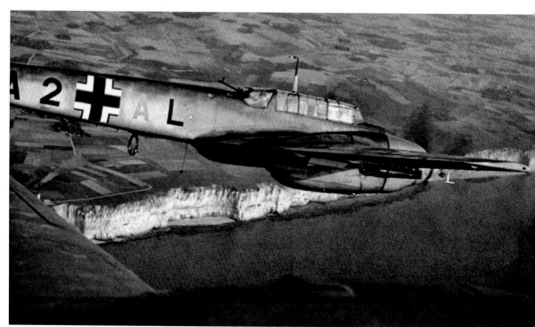

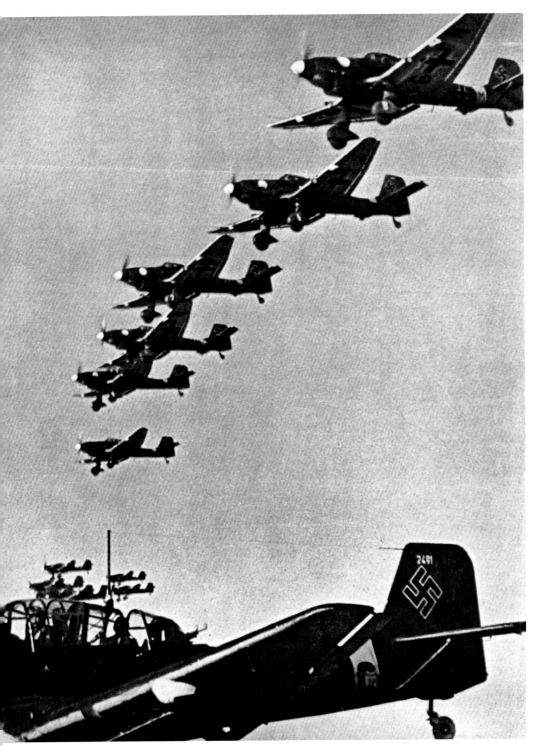

Above: A formation of Stukas. The dive-bombers were used extensively in the early stages of the Battle of Britain, but their slow airspeed made them vulnerable to the much faster Hurricanes and Spitfires of the RAF.

Above: Three wartime portraits of RAF personnel. From left to right, Sergeant Parker by Eric Kennington, Corporal Robins of the WAAF was painted by Laura Knight, and Squadron Leader Crosseley, another by Eric Kennington.

Left: Everyone had to do their bit. Volunteer spotters take to the roof of their business premises to keep an eye out for enemy aircraft. Come rain or shine they worked in shifts, equipped with a pair of binoculars and two telephones with which to report sightings.

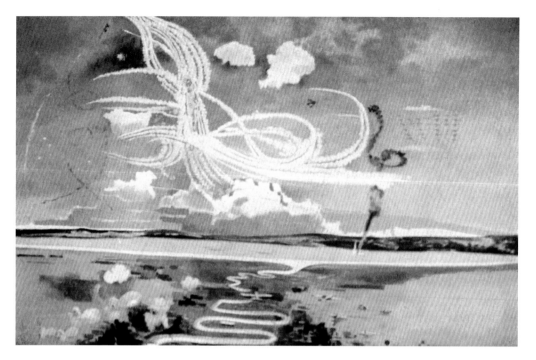

Above: Paul Nash's painting has become an iconic image of the Battle of Britain. *Below:* The story of Britain's defenders, including the countless unsung heroes who manned the guns, operated the balloons and fought the fires, were told through these official HMSO booklets issued during the war. *Roof Over Britain* was published in 1943, *Front Line* in 1942.

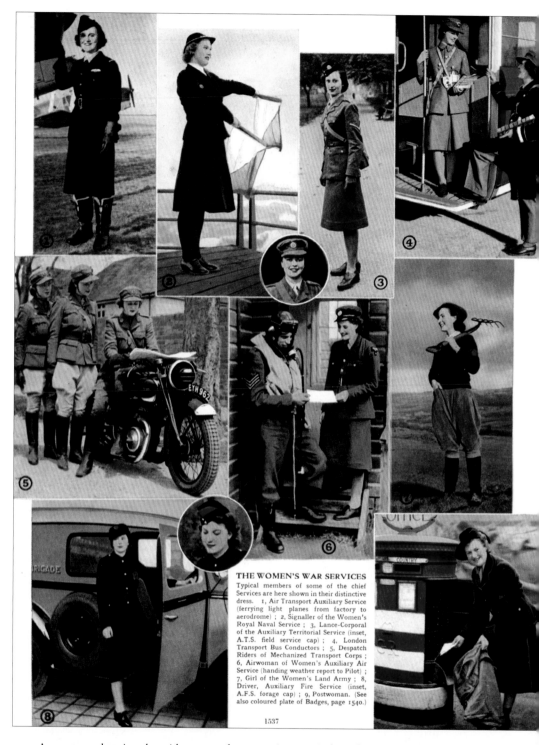

THE WOMEN'S WAR SERVICES
Typical members of some of the chief Services are here shown in their distinctive dress. 1, Air Transport Auxiliary Service (ferrying light planes from factory to aerodrome) ; 2, Signaller of the Women's Royal Naval Service ; 3, Lance-Corporal of the Auxiliary Territorial Service (inset, A.T.S. field service cap) ; 4, London Transport Bus Conductors ; 5, Despatch Riders of Mechanized Transport Corps ; 6, Airwoman of Women's Auxiliary Air Service (handing weather report to Pilot) ; 7, Girl of the Women's Land Army ; 8, Driver, Auxiliary Fire Service (inset, A.F.S. forage cap) ; 9, Postwoman. (See also coloured plate of Badges, page 1540.)

1537

A montage showing the wide range of war services carried out by women. They include 1. Air Transport Auxiliary Service, 2. Royal Naval Service, 3. Auxiliary Terriorial Service, 4. London Transport, 5. Mechanised Transport Corps, 6. Women's Auxiliary Air Service, 7. Women's Land Army, 8. Auxiliary Fire Service, 9. Postwoman.

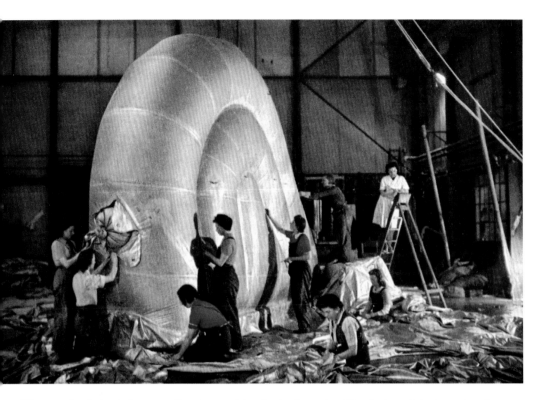

Women also helped the war effort by working in the factories. Here's the original caption for these images: 'Girls and housewives, rich and poor alike, the women of Britain have served in the forces or striven in factories so that their menfolk could fight. Making barrage balloons, above, and rubber dinghies, below.'

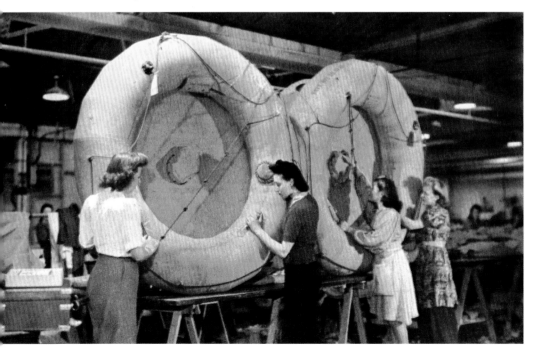

Above: Junkers Ju 52 transport aircraft carrying German paratroopers over the Netherlands. In May 1940 these aircraft were involved in the first large-scale airdrop as part of the Battle of The Hague. *Below:* In April 1940 a force of fifty-two aircraft dropped troops in an airborne attack on Denmark and Norway.

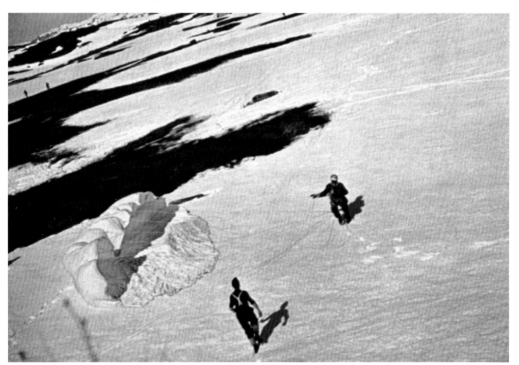

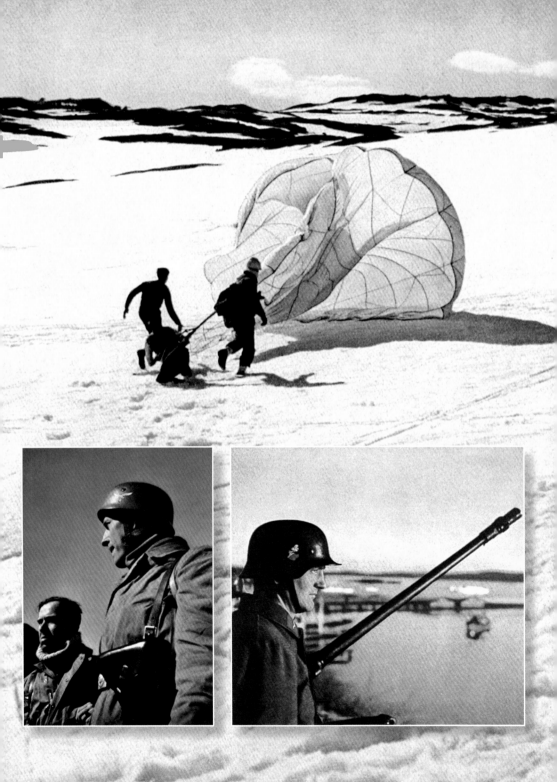

Fallschirmjäger, German paratroops, landing on snow on 9 April 1940 as part of the operation to protect Norway and Denmark's neutrality against Franco-British aggression. *Inset:* German paratroops, in this instance photographed after the invasion of Crete, plus anti-aircraft coastal batteries in occupied Norway.

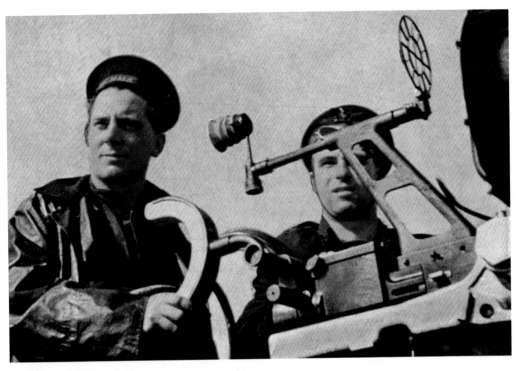

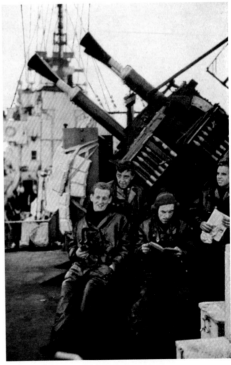

Three photographs taken on British Hunt class destroyers while on patrol and convoy duty in the North Sea. *Top:* Ready with a 2-pdr pom-pom known as the 'Chicago Piano'. *Lower left:* Divets being swung out to drop down shore boats. *Lower right:* Crew of an Oerlikon anti-aircraft gun.

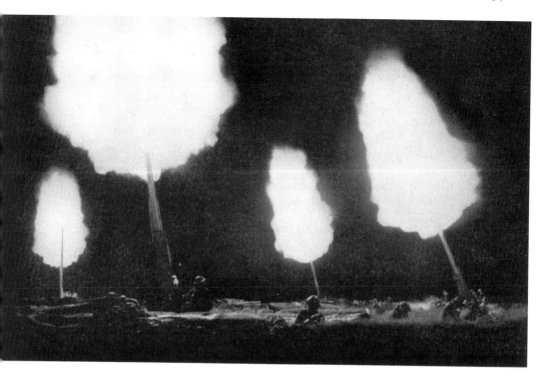

Above: The anti-aircraft guns
blaze in unison to throw up a
'wall of fire' against incoming
enemy bombers.

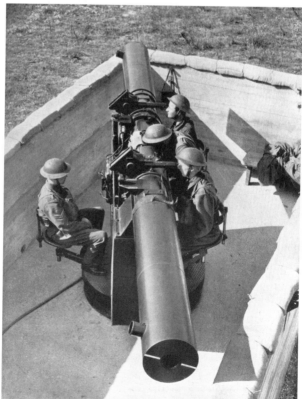

Right: Men of an anti-aircraft
battery operating a stereoscopic
range and height indicator to
direct the fire of the guns. This
is a particularly large example;
handheld versions were used
by field gun and smaller anti-
aircraft gun teams on both
sides.

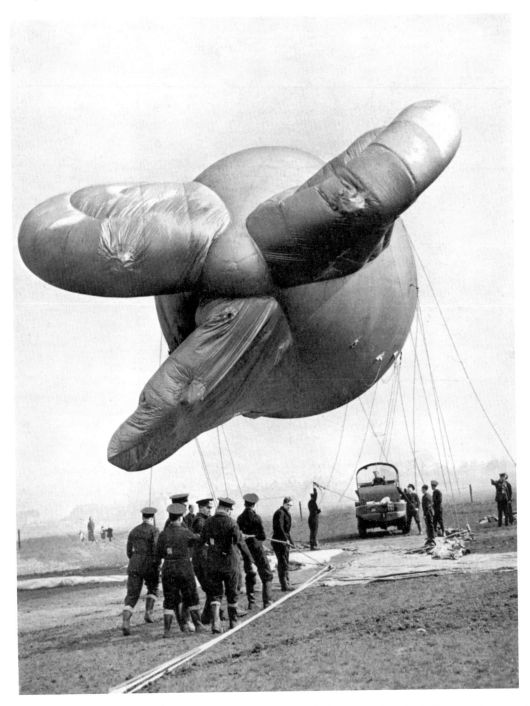

A barrage balloon team with their balloon close-hauled. Quite often the balloons only went up to full height when incoming enemy aircraft were expected. The balloons were filled with hydrogen gas and their cables deterred low-flying attacks while also keeping the enemy at a predetermined height where the anti-aircraft guns had more chance of picking them off. Note that this is an all-male team as the female balloon teams were not introduced until 1942.

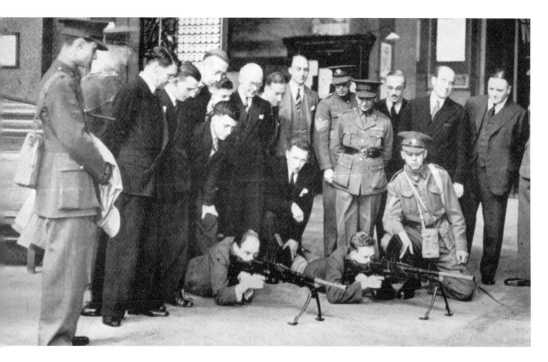

The real *Dad's Army*: by the end of June 1940, membership of the Local Defence Volunteers had reached the million mark, and at Churchill's suggestion they were renamed as the Home Guard in the following month. *Above:* Members and clerks of the London Stock Exchange get into training and are shown receiving Bren-gun instruction. *Below:* LDV personnel at the firing range. At first they had armed themselves with shotguns and even broom handles converted into pikes, but as the Home Guard they were issued with proper uniforms and standard weapons.

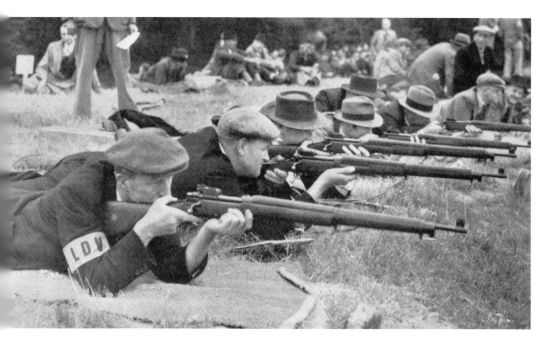

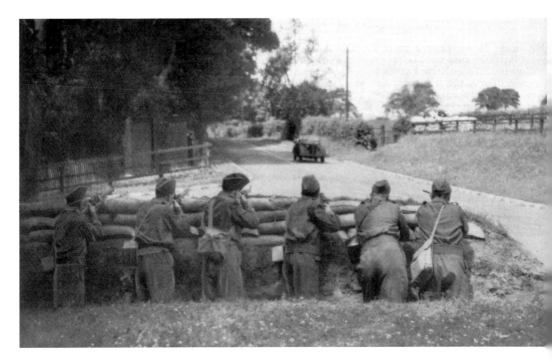

NICE NEW TOY. " Let me see, now ; that's everything.
Respirator, tin-hat, Sten-gun . . ."

Above: 'They shall not pass.'
A unit of the Home Guard has
complete command of this road.
But no chance is taken and they
are entrenched and sheltered by
sandbags.

Left: It was all too easy to poke
fun at the men of the Home
Guard and they were frequently
the butt of well-intentioned
humour. This cartoon was
published in one of the wartime
newspapers.

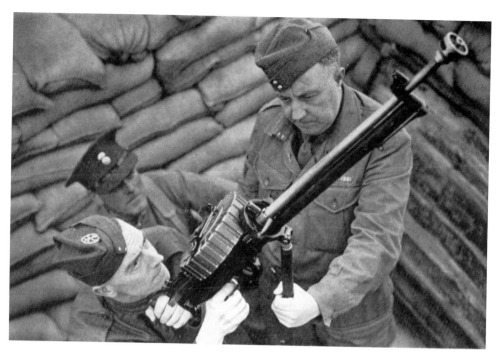

Above: Instruction for the Home Guard at the Weapon Training School in the Western Command. Soldiers from the regular army give the Home Guard a week's training in the use of modern weapons. *Below:* Mass production of Molotov cocktails. They were considered to be an effective weapon against armoured divisions and were adopted by the Home Guard.

Above: The Lord Mayor of London addresses a parade of the Auxiliary Pioneer Corps, following a march through the City. *Below:* Field-Marshall Lord Milne, Colonel Commandant of the APC, is 'chatting' with some of the men who had distinguished themselves by their rearguard action in the withdrawal from Dunkirk.

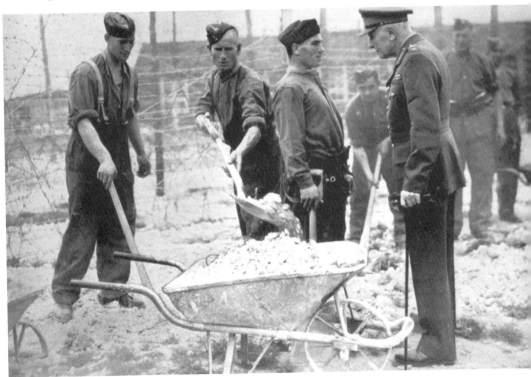

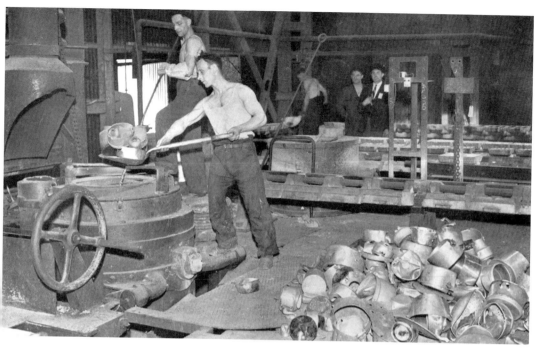

In July, Lord Beaverbrook's call for aluminium pots and pans to build more Spitfires met with a massive response. The pans were delivered to depots set up by the Women's Voluntary Service. Part of the haul is being placed in the smelting furnace at a Ministry of Aircraft Production Centre, above. While Spitfires caught the popular imagination, Beaverbrook had said that the aluminium would also be used for Hurricanes, shown below, Blenheims and Wellingtons.

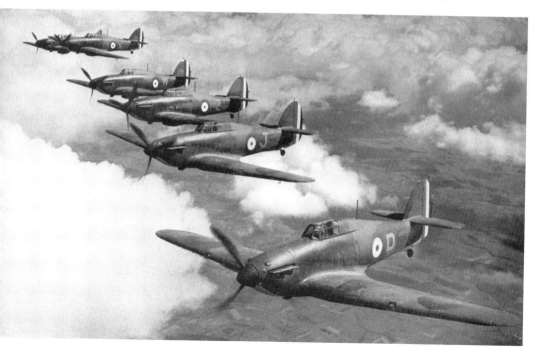

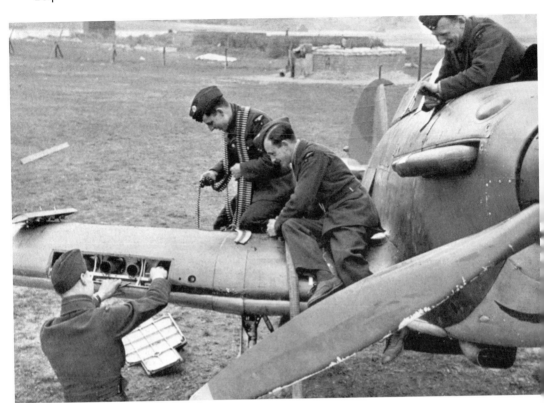

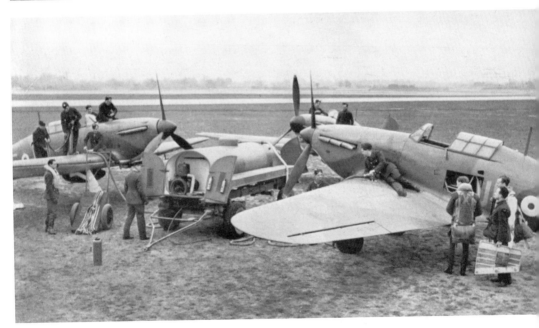

Above: Hurricanes being prepared for their next sortie, with the machine guns being checked and replenished with ammo, and a refuelling bowser filling the tanks of two aircraft at the same time.

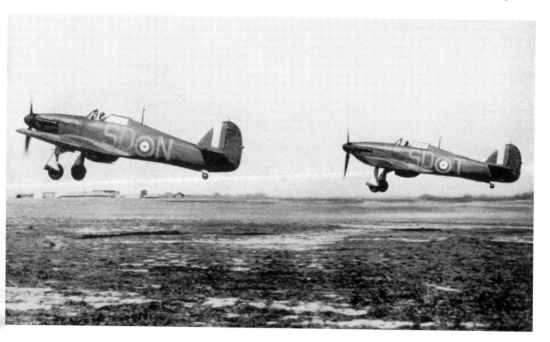

The aircraft of the 'few'. *Above:* A pair of Hawker Hurricanes take off from an RAF fighter station in southern England. *Below:* Six Supermarine Spitfires flying in formation, scanning the sky to seek and join the enemy bombers in battle. In August 1940 the Luftwaffe had begun their attacks by targeting British airfields in an attempt to cripple the RAF, but later the Germans would switch tactics, with London as the main target. At the height of the Battle of Britain it was estimated that more than 1,000 German aircraft were being sent over Britain daily.

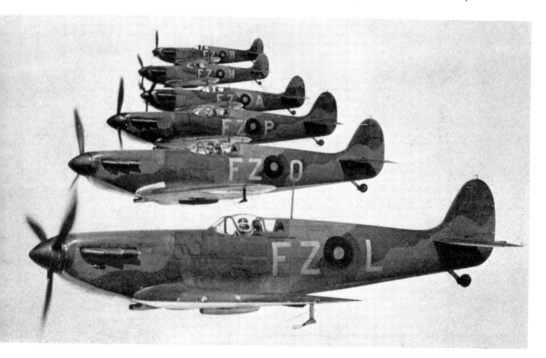

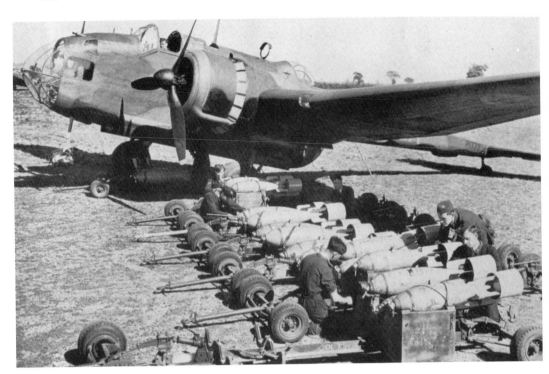

Other aircraft of the RAF. *Above:* The Handley Page Hampden medium bomber had been introduced in 1938 and, together with the Wellington and Whitley, it was used extensively by Bomber Command in the early years of the war. It was retired in 1943. *Below:* The Douglas Boston was one of the new types of American-built aircraft being supplied to the British. This twin-engined light bomber entered service with Bomber Command in 1941.

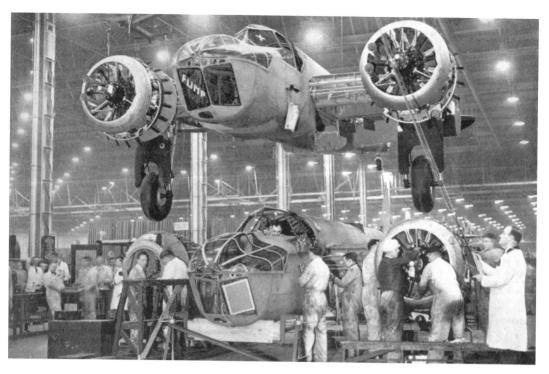

Above: A Bristol Blenheim light bomber under construction at a Bristol Aeroplane Company factory. This pre-war design was the first British aircraft to have an all-metal stressed-skin construction. *Below:* 225 Westland Lysanders were built under licence in Ontario, Canada.

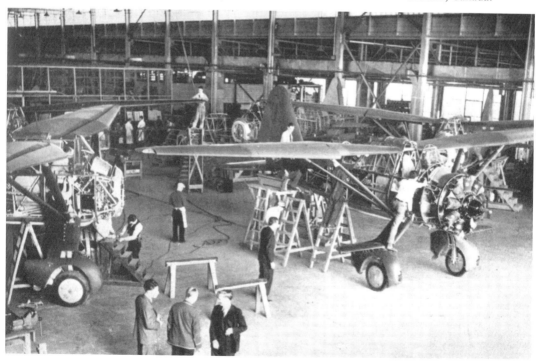

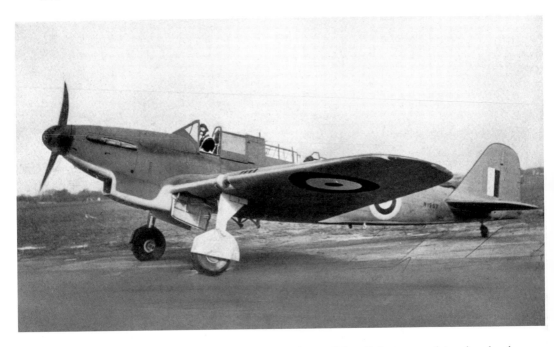

Aircraft of the Fleet Air Arm. *Above:* The carrier-borne Fairey Fulmer was claimed to be the fastest aircraft in the service of the Royal Navy. Introduced in May 1940, a total of 600 were built at the factory in Stockport between January 1940 and December 1942. *Below:* Another Fairey, the single-engine Albacore was a torpedo carrier, reconnaissance aircraft and dive-bomber, intended as a replacement for the aging Swordfish, although the two ended up operating alongside each other. Carrier-borne, with a three-man crew, it was nicknamed the 'Applecore'.

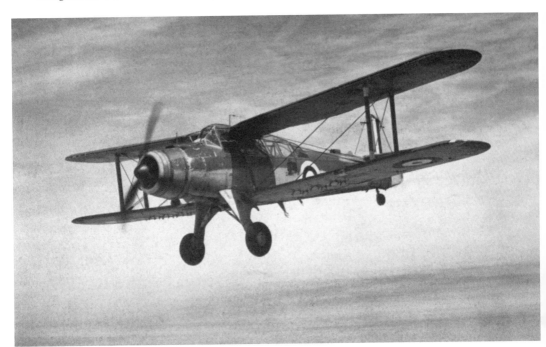

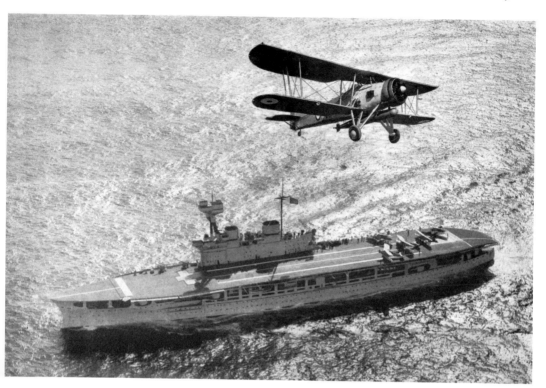

Above: A composite photograph showing a Fairey Swordfish and the aircraft carrier HMS *Eagle*. The Swordfish carried an 18-inch torpedo. Nicknamed the 'Stringbag', this outmoded aircraft had first flown in April 1934 and was introduced into service with the FAA in 1936. Even so, it continued in service until the end of the war in 1945.

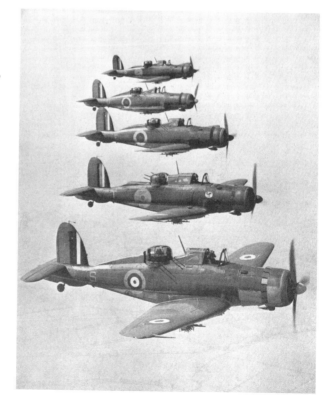

Right: A formation of Blackburn B-25 Rocs. The rear gun turret was a feature on several British aircraft at the time. Only 136 of these aircraft were built under subcontract by Boulton-Paul at their works in Wolverhampton.

As the RAF expanded, the call went out for more recruits. *Above:* This photograph shows new wireless operators in training. They are receiving messages sent out from the trainers sitting at the table. *Below:* More practical training, with the trainee operator and instructor inside an aircraft.

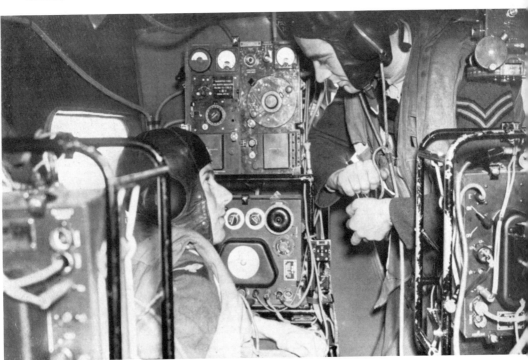

AUGUST 1940

Above: London's Tower Bridge stands out in sharp silhouette against a sky lit by flames. The fires had been started in the big daylight raid of 7 September, and the blaze served as a beacon for another wave of bombers that came after nightfall.

Battle of Britain

For three months and three weeks in the summer of 1940, the skies of southern England were full of the vapour trails of aircraft, spiralling through the air in fights to the death. Some 2,800 German bombers and fighters were thrown against the might of the RAF, a mere 750 fighters, with orders to pummel Britain into submission. It was the world's first battle fought almost exclusively in the skies and the intent of the Germans was to smash the RAF's air superiority over Britain and provide German air cover for the forthcoming Operation Sealion, the invasion of the UK. After six weeks consolidating its gains in France, and mopping up the last resistance, the focus turned to across the Channel. On 10 July, air raids took place on convoys travelling up the English Channel as well as at ports and harbours such as Portsmouth and Southampton. Herman Göring, the leader of the Luftwaffe, had told Adolf Hitler that his aircraft alone could destroy the RAF and make invasion possible.

Hitler had hoped that Britain would sign an armistice and that his armed forces could concentrate on war in the East, against Russia. It was not to be and by 16 July, Hitler had put in place the plans for everything needed for the invasion. All he needed was air superiority! The navy's plan was to have a narrow beachhead at Dover but the army wanted a series of attacks along the South Coast. The

Below: The wreckage of a Dornier shot down on 13 August 1940.

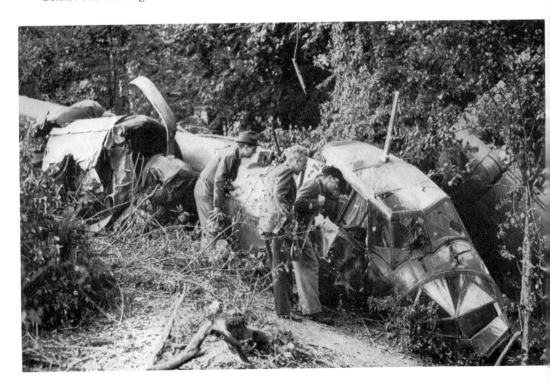

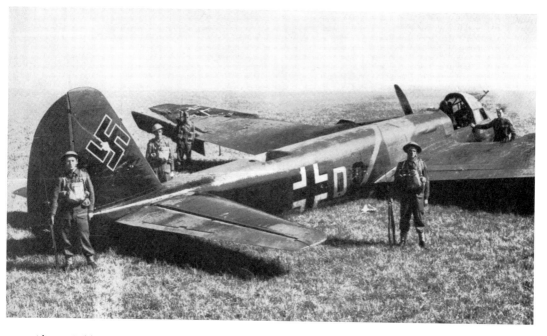

Above: Soldiers stand guard on a Junkers Ju 88 brought down near the South Coast, also on 13 August. Around seventy Luftwaffe aircraft were lost that day.

Kriegsmarine had been severely mauled in Norway and had lost many vessels, while the British still retained much of their Home Fleet. Without the air victory, invasion would be impossible and the Stuka dive-bombers would not be capable of operating. The hope was that the dive-bombers could keep the Royal Navy at bay, but deep down the German commanders knew the invasion was unlikely. That is, everyone apart from Herman Göring, whose reputation was at stake. Facing the Luftwaffe's Messerschmitt BF 109s were Spitfires and Hurricanes, piloted by skilled fliers, who were fighting for their country's very existence.

Around 435 pilots had been lost during the Fall of France and this lack of skill was to tell in the early days of the campaign. Around 1,103 Allied pilots faced a battle-hardened core of 1,450 Luftwaffe pilots. One thing that the RAF had in its favour was that its pilots, who had to bail out, often did so over friendly territory, and could go back into battle in a new aircraft, but each German that parachuted onto British soil was lost forever to the Luftwaffe. Britain had one other advantage, that of radar, developed pre-war but very much in use in the early days of the fighting. The Chain Home radar system and a series of control centres could control the RAF pilots and send them to where they were needed. German formations could be seen getting into position over the Channel and aircraft put into the air only when it was necessary. This helped keep pilots fresh and also conserved fuel and ammunition.

German planners concluded that the radar and control centres they knew of were not flexible, and that Britain would run out of aircraft at some point. They

Above: Ground staff of a Czechoslovakian fighter squadron attached to the RAF, shown at work rearming a Hurricane. *Below:* The squadron was led by two RAF officers and they are reading telegrams from the Secretary of State for Air congratulating them on successful engagements.

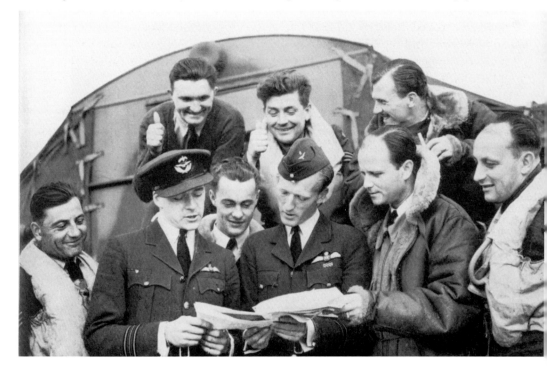

knew little of Britain's strengths nor of its weaknesses and a lack of planning ensured they would not win the Battle of Britain. Haphazard choice of targets, a change in what was being attacked and a lack of awareness of RAF tactics saw the ultimate defeat of the Luftwaffe.

While the dogfights took place above England's skies, the bombers came at the UK, on day and night raids; they initially attacked the RAF bases but began to change to night-time bombing, including civilian targets.

The Battle of Britain could be split into a few distinct phases. From 10 July to 11 August, the focus of attacks was on the Channel. Between 12 and 23 August, coastal airfields and radar stations bore the brunt of the assault. From 24 August to 6 September a more concerted effort was made to destroy Fighter Command's airfields and aircraft, and from 7 September, just as the RAF had been worn down, the focus changed to civilian targets in the hope that the British public would succumb to the hail of bombs.

Eagle Day was 13 August, and the Germans threw themselves at the RAF's bases, attempting to destroy as many aircraft as possible. The largest number of sorties by the Luftwaffe was on 15 August, with the whole coast being under attack. Thinking most of the RAF was in the south, the pilots of Luftflotte 5 were rather shocked to find that the north of England was just as well defended. By the 18th, the Ju 87 Stuka had proved to be doomed against superior fighters and was withdrawn. London was bombed on 24 August and RAF bombers sent to Berlin the following evening in retaliation. The period in September was the most critical, not that the Germans realised it, and a change of tactics helped save the RAF from defeat. On 7 September day and night raids, involving over 400 bombers and 600 fighters, destroyed much of the East End of London and the Docks. The RAF had time to recover and repair the airfields, helping keep the Germans from winning. On 17 September, after huge defeats on the 15th, the invasion was called off and the Luftwaffe changed tactics again, concentrating on night bombing of civilian and industrial targets.

The Battle of Britain ended in victory for the British and their allies, with some of the best results coming from Polish and Czech squadrons. Hitler's planned invasion was no more and Britain had lived to fight another day, with grateful thanks to the pilots, air and ground crew of the RAF. In the words of Winston Churchill himself, 'this was their finest hour'.

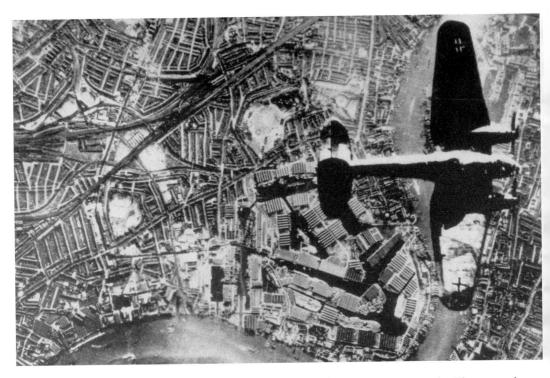

Above: The unmistakable shape of a Heinkel He 111 bomber, flying over the Thames and London's docks in 1940. *Below*: In customary fashion, Winston Churchill is out and about inspecting the extent of the damage caused by air raids in Central London and the East End.

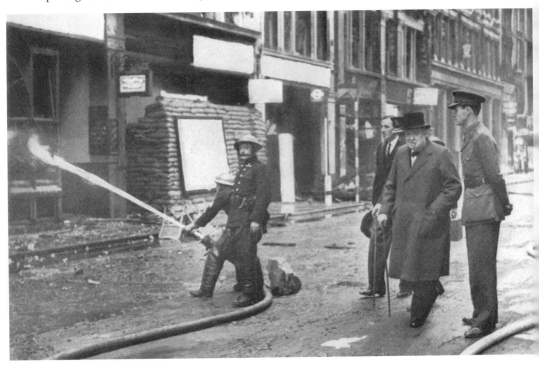

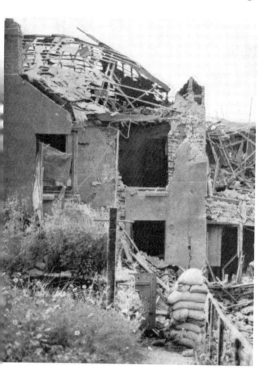

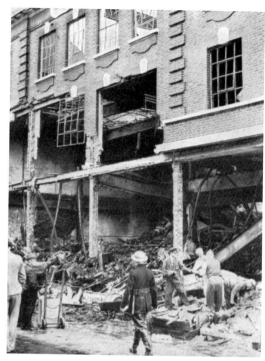

Similar scenes of destruction were to be found in many other towns and cities. *Above:* A house in south-east England, destroyed by bombs on 12 August, and damage to buildings in Southampton. *Below:* A shattered row of shops in Croydon, attacked on 18 August.

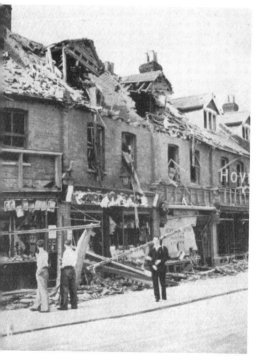

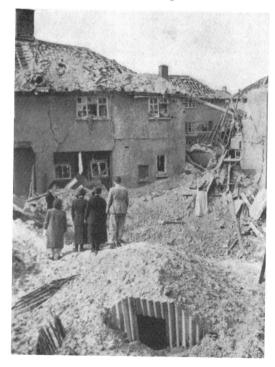

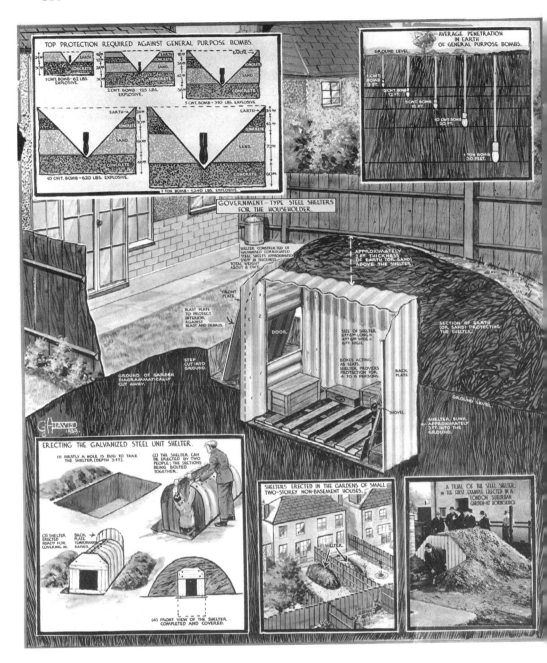

Above: A diagram published in *The Illustrated London News.* 'These shelters are capable of holding from four to six persons. It is hoped eventually to supply them for all houses with not more than two storeys, with sufficient garden space, in all vulnerable areas ... The shelters, are constructed of very strong galvanised corrugated steel sheets, and have been subjected to rigorous tests to ensure their strength when erected to take the weight of any debris that might fall upon them from the type of house for which they are designed. They are made in sections and can be put together by two people without any special skills or experience.'

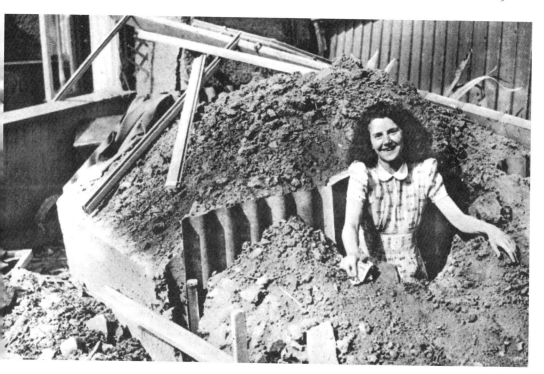

Above: Mrs E. Cullen is shown smiling as she emerges from the emergency exit at the back of her Anderson shelter. Debris from a bomb blast had blocked the main entrance. Published in *The Illustrated London News*, this photograph is typical of a string of such images that demonstrated the almost indestructability of the shelters.

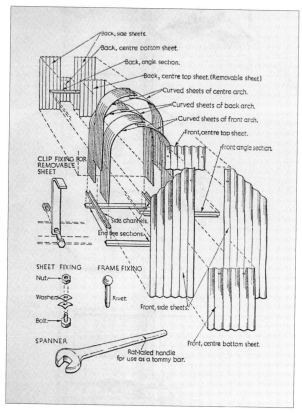

Right: Instructions for assembling an Anderson shelter.

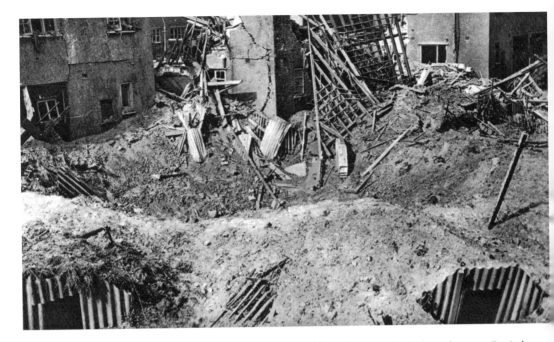

Above: Two Anderson shelters have survived the blast that wrecked these houses. Buried beneath a layer of soil, the shelters were extremely efficient in absorbing the effects of a bomb blast.

FIGURE 5

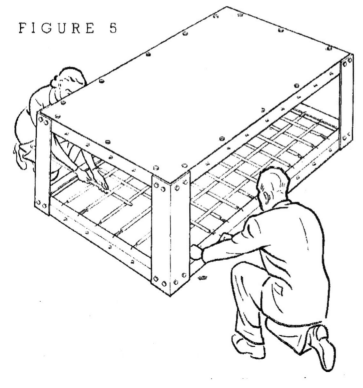

Left: For those without a garden the Morrison shelter was an indoor alternative. It had a steel frame and top, with wire mesh sides. Just big enough for two people to sleep side by side, there was no standing room. As with the Anderson shelters, these were also designed for self-assembly.

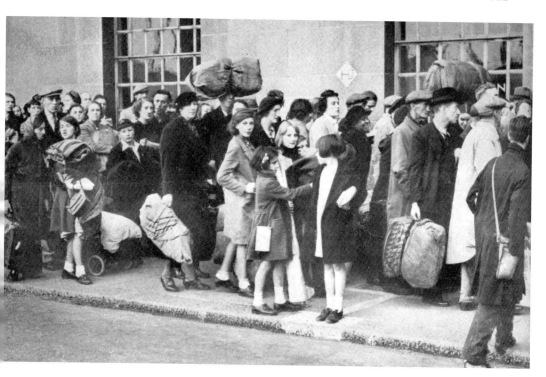

Above: Armed with mattresses and cushions, these Londoners queue outside a public shelter in the basement of an office building. *Below:* The Queen talks to children in a Southwark shelter. They had bunk beds and some basic amenities in the shelters.

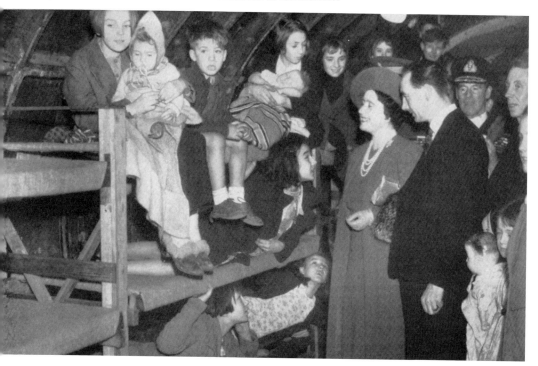

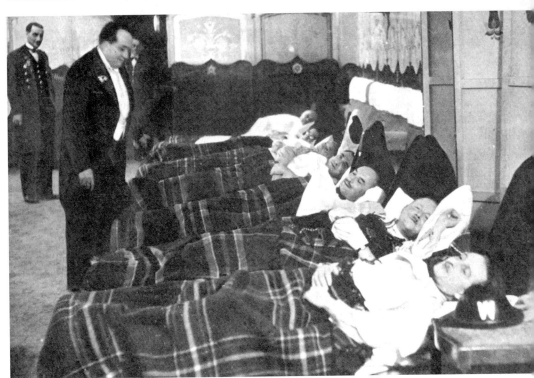

Above: As in the First World War, there was a sense that those with enough money had a more comfortable time of it. These photographs, published in the *Picture Post* in 1940, show diners at a London hotel being tucked in for the night after their dinner. 'If you stay out to eat, you stay put to sleep until the siren calls you for breakfast as the milkman calls in the morning.'

SEPTEMBER 1940

Above: Luftwaffe crew are marched off under armed escort as their Heinkel He 111 burns in the background. It was shot down by a Hurricane off the South Coast after a raid on London.

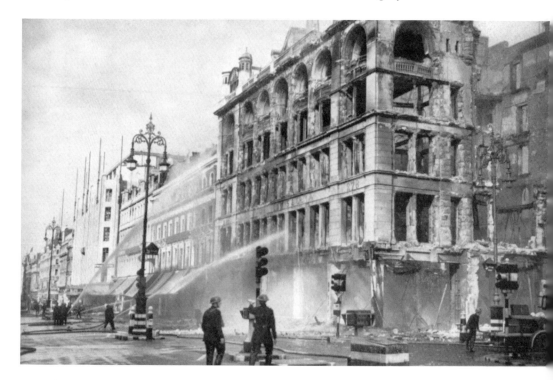

The bombing of London continues. *Above:* The frontage of the John Lewis store in Oxford Street. The firemen continue to dowse the flames, but the building has been reduced to a shell. *Below:* Firemen at work on a blaze in Chancery Lane.

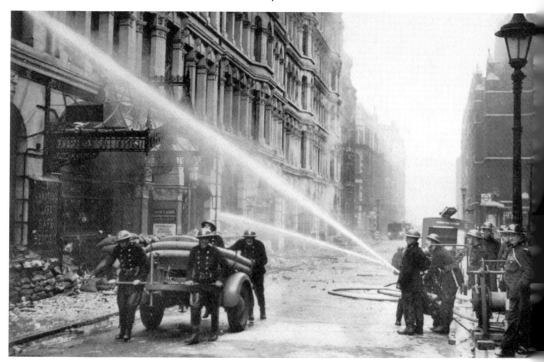

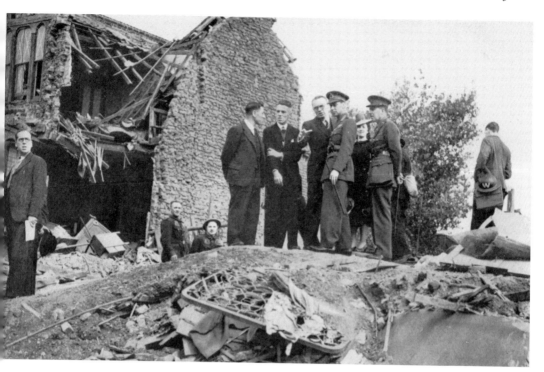

The King and Queen were frequent visitors to the bomb-damaged areas of London, especially the East End which suffered badly because of its close proximity to the docks. *Above:* On 9 September, the King spent three hours examining the damage done to homes and taking time to talk to the householders and members of the fire and rescue services.

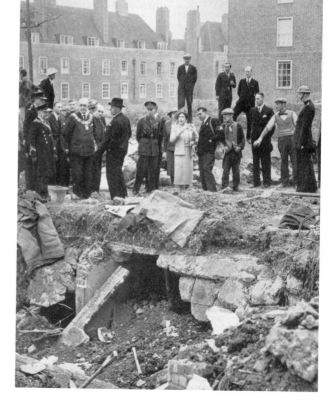

Right: The Queen looks visibly shocked by the extent of the devastation on a another visit, on 11 September. They are accompanied by Sir John Anderson, the Minister for Home Security.

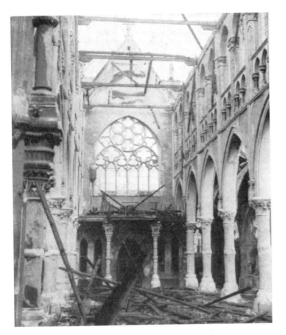
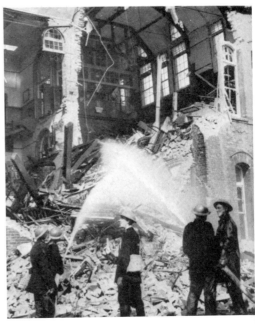

Obviously the bombs did not discriminate. *Above:* The Church of Our Lady of Victories, Kensington, after a bomb had dropped through the roof, and a burning school building in East London. *Below:* A scene of havoc in the City, looking towards Southwark Bridge and the Thames. Note the bomb crater on the left-hand side of the street.

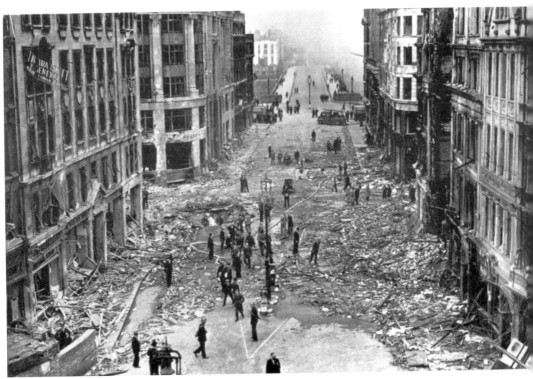

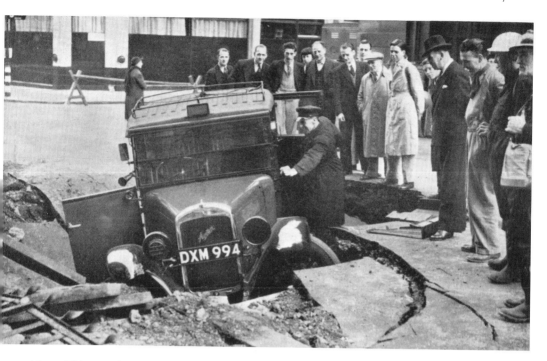

Above: This taxi driver had a lucky escape when his vehicle was flung into the air and dropped into a bomb crater during a raid on 27 September. The cab looks remarkably undamaged. *Below:* Unexploded bombs (UXBs) were a constant hazard. A bomb disposal team is on the scene working on the bomb, although this photograph might be a re-enactment judging by the proximity of the cameraman.

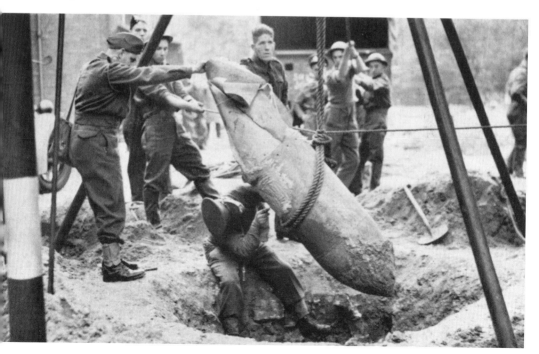

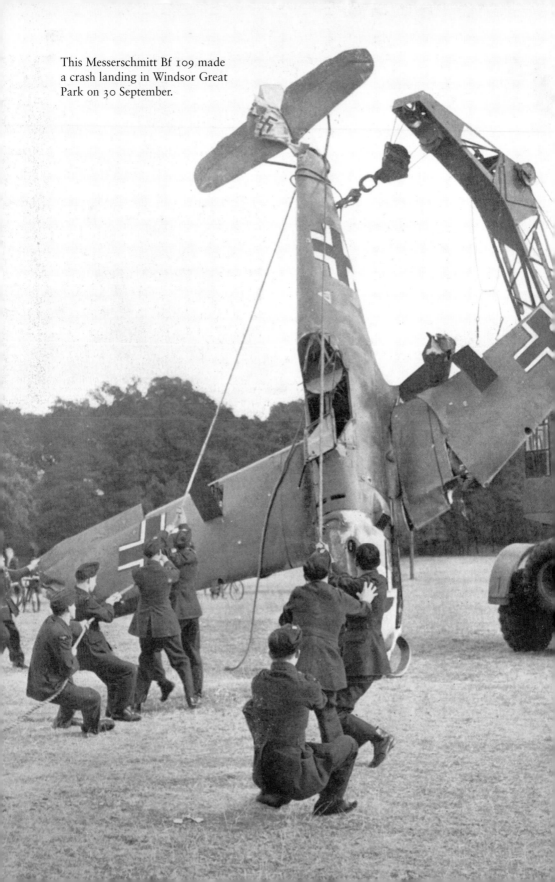

This Messerschmitt Bf 109 made a crash landing in Windsor Great Park on 30 September.

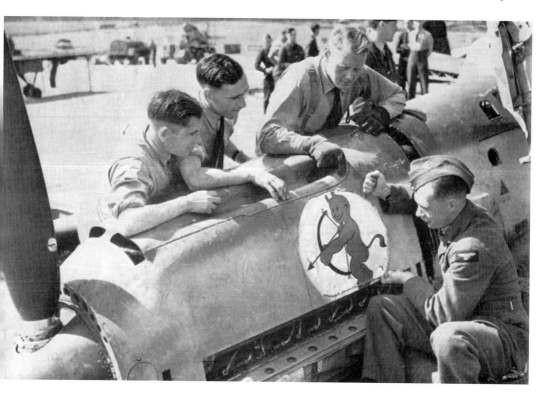

Above: Examining another Bf 109. In most cases the damaged aircraft were transported to dumps, there to be broken up and the metal reused to build more Hurricanes and Spitfires.

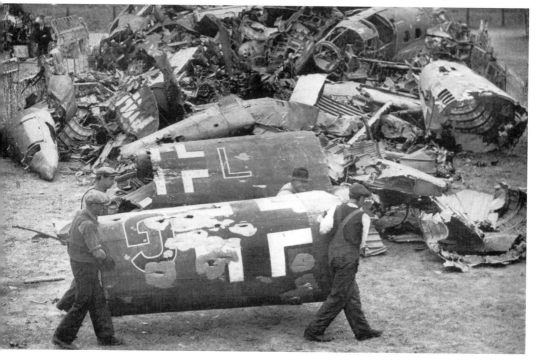

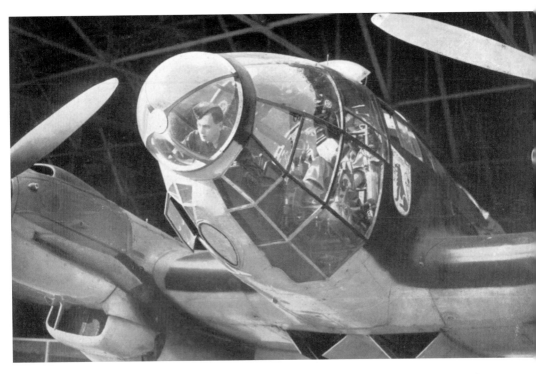

Some aircraft, in particular new types or variations, were examined very carefully for new technological developments. A handful were repainted with British markings and used for test flying and to give demonstrations to teach RAF personnel about their particular flight characteristics. *Above:* A Heinkel He 111 is being scrutinised at an RAF base. *Below:* The fuel tank from a Heinkel is closely examined by an expert, and a cannon is taken away for testing.

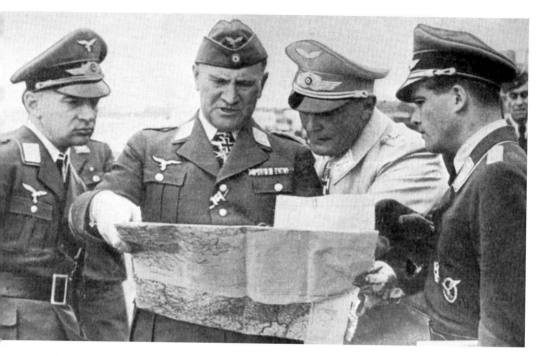

It was becoming clear that Göring, shown above in the light-coloured uniform, had failed in his objective to gain air superiority above Britain. On 17 September Adolf Hitler cancelled Operation Sealion – the invasion of Britain – and ordered that the invasion forces should be dispersed. Vastly outnumbered by the aircraft of the Luftwaffe, with around 2,000 German aircraft against 700 British fighters, the 'Few' had won through. However, the bombing raids against British cities and the industrial centres of the Midlands would continue.

Right: A British cartoon deflating the Nazi air force myth.

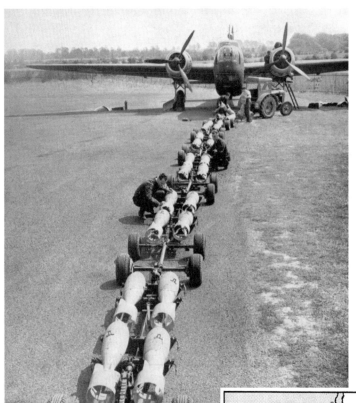

Left: A Wellington bomber being prepared for a raid on Germany. Britain's answer to the Blitz was an intensification of the nightly attacks on the German war machine.

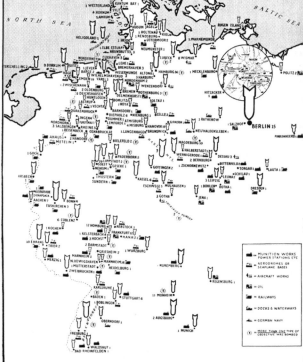

Right: An official map showing the RAF bombing offensive against Germany up to 30 September 1940. The size of the bomb symbols indicates the varying intensity of the attacks. It shows how Bomber Command was directing its attention against the enemy's war production facilities, in particular the munitions and aircraft works, as well as oil refineries, docks, railways and the German navy.

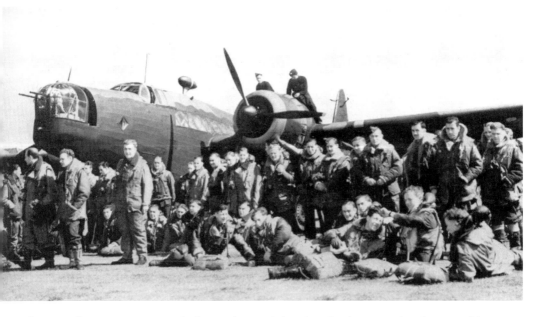

Above: Wellington crews pose in front of one of the aircraft after returning from a raid on Berlin. Note the black night-time camouflage on the underside of the wings and on the side of the fuselage. *Below:* An intelligence officer checks reports at a post-mission debriefing.

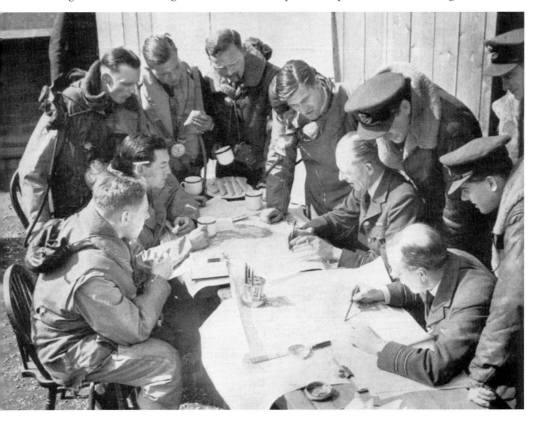

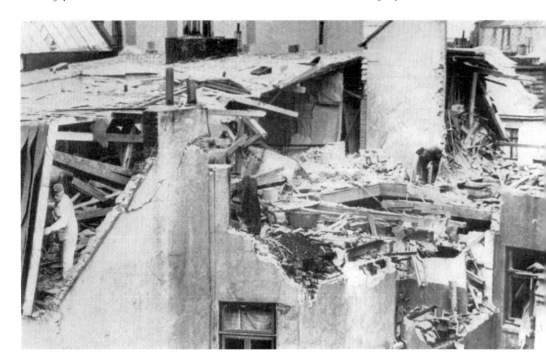

Above: In scenes already familiar to Londoners, the citizens of Hamburg examine the damage caused by a British air raid on the city.

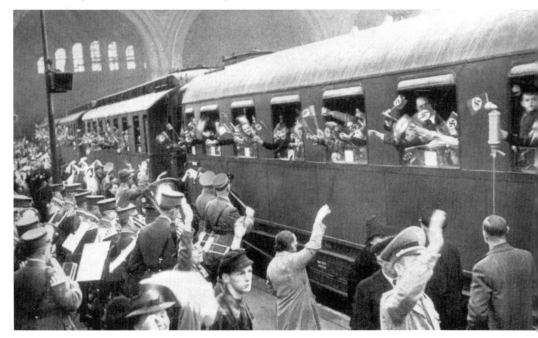

Above: A train pulls out of a Berlin railway station crowded with onlookers and a brass band. The train is packed with children waving swastika flags as they are evacuated to safety following the RAF's bombing raids on the city.

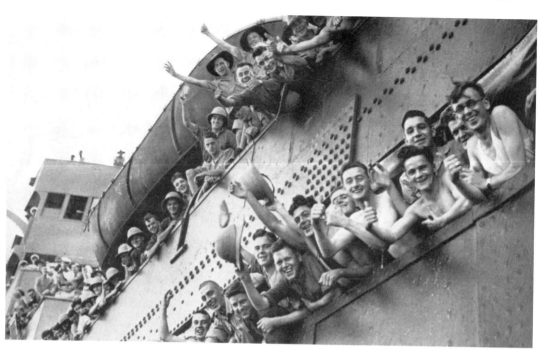

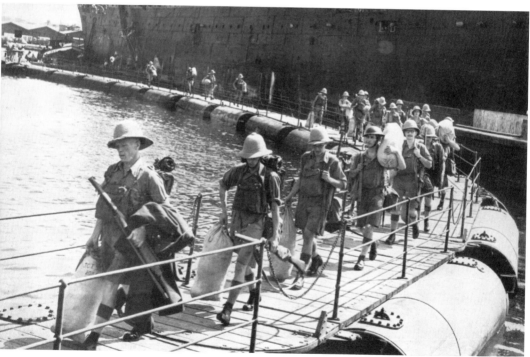

Above: Two images showing a convoy of troopships arriving and disembarking in Egypt after the long voyage from England under the protection of a Royal Navy escort. The men cheer as they arrive at the docks. As the war progresses, the Middle East and North Africa assume an ever greater significance.

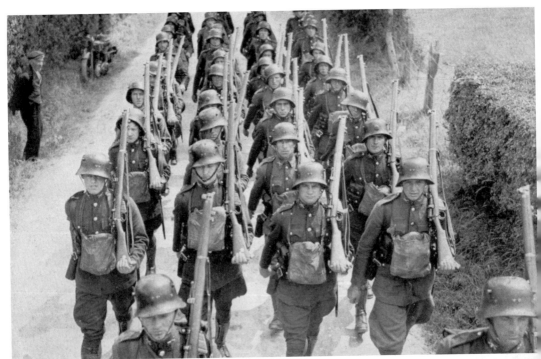

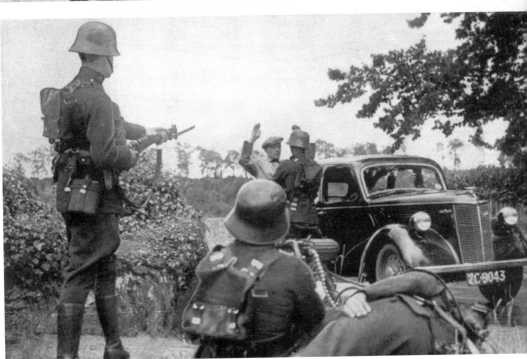

With their coal scuttle helmets you would be forgiven for thinking that these were German soldiers on the march, but in fact they are the men of neutral Ireland's army. In the lower image they have called upon a motorist to halt and submit to a search.

OCTOBER 1940

Above: On 13 October 1940, the fourteen-year-old Princess Elizabeth made her first radio broadcast. Addressing the 13,000 children evacuated overseas, she said, 'When peace comes, remember it will be for us, the children of today, to make the world of tomorrow a better and happier place.' Princess Margaret was at her side.

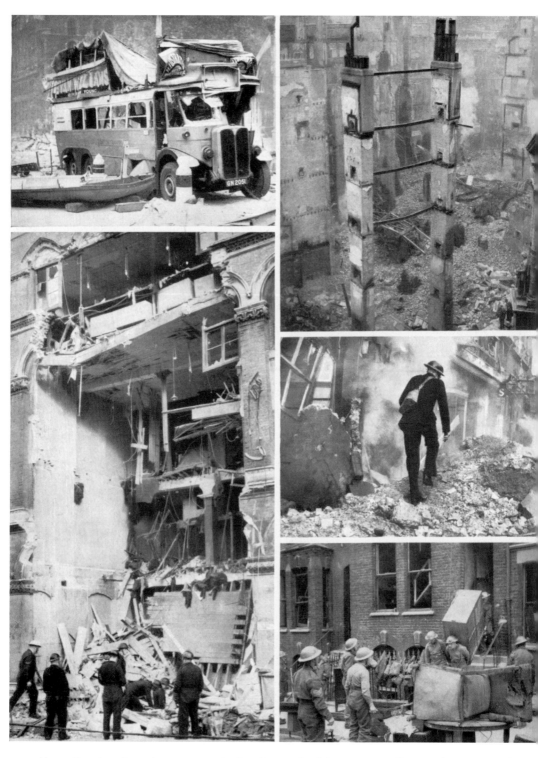

Above: 'London shows its war wounds. Another week of the air war is illustrated in a series of photographs taken in the London area.'

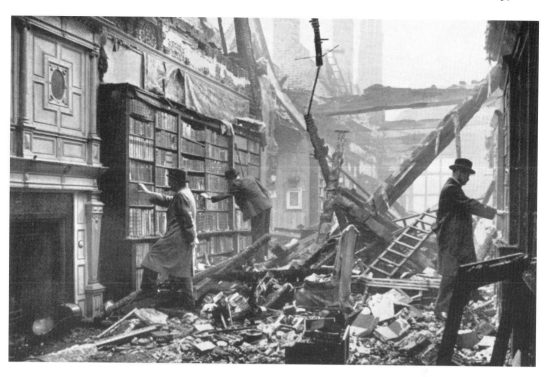

Above: The ruins of the library at Holland House, which was badly damaged by incendiary bombs.

Right: An incendiary bomb pierced the roof of St Paul's near the high altar at the eastern end of the cathedral. Thankfully the diligence of the fire spotters and cathedral staff saved Wren's iconic building from further damage.

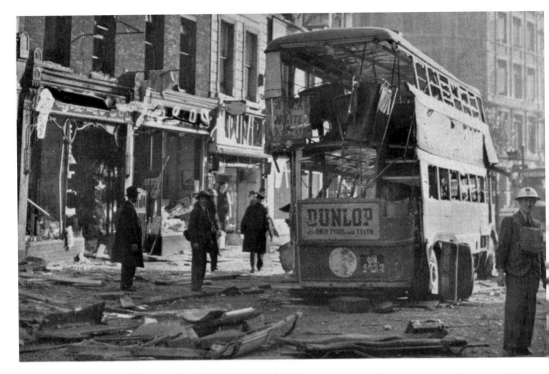

Above: A London street after an early morning raid during rush hour on 8 October. Two buses were wrecked and considerable damage was done to business premises.

Left: Two young nurses are summoned to the scene of a daylight bomb explosion.

REGULARS. "Good evening, George. Any letters?"

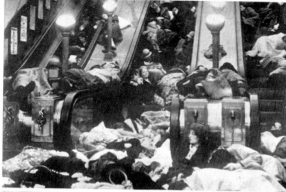

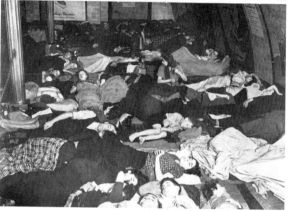

Above and right: The government had attempted to dissuade people from using Underground stations as a refuge because of concerns about disease and the lack of sanitation. But the public voted with their feet and restrictions were lifted. *Below:* A policeman inspects the damage caused by a direct hit on a public shelter.

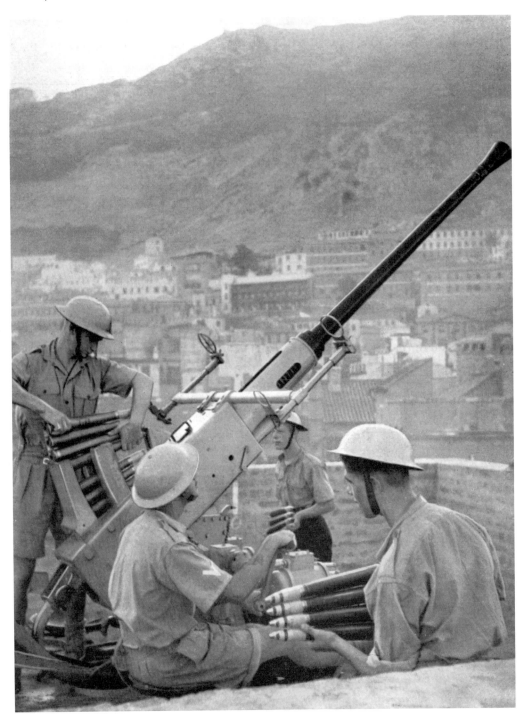

Above: An anti-aircraft gun team defending Gibraltar.

NOVEMBER 1940

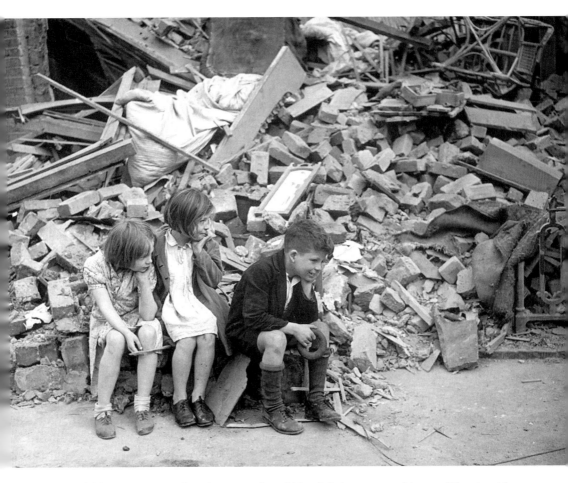

Above: Children in East London sit among the rubble of their streets and homes. The air raids had changed the city landscape irrevocably.

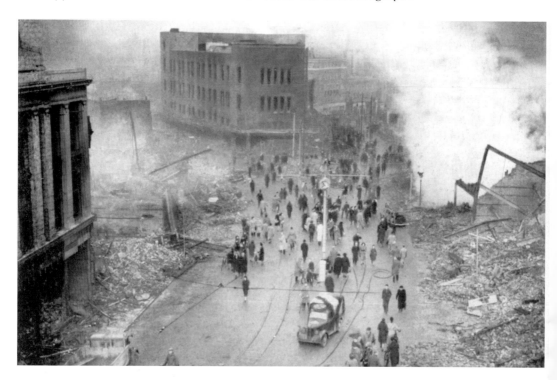

On the night of 14/15 November, over 400 Luftwaffe bombers raided Coventry, leaving the city in ruins and killing 500 civilians. *Above:* In the ten-hour raid, one of Coventry's main shopping streets has been reduced to rubble. *Below:* But the greater shock was the destruction of the fourteenth-century cathedral, with only the outer walls, tower and spire remaining.

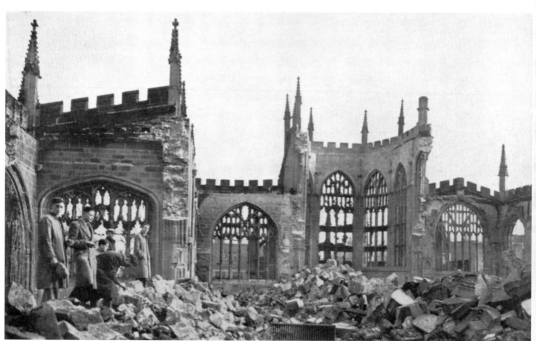

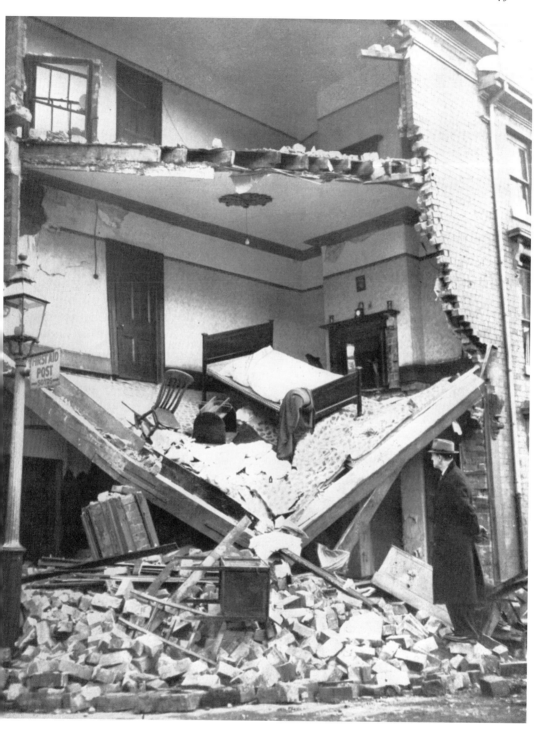

Above: In a Midland town, a bomb has exposed the inside of someone's home like a crazy doll's house. Furniture has slid to the corner while ornaments and a clock remain on the mantelpiece. There is a dressing gown draped across the bedpost.

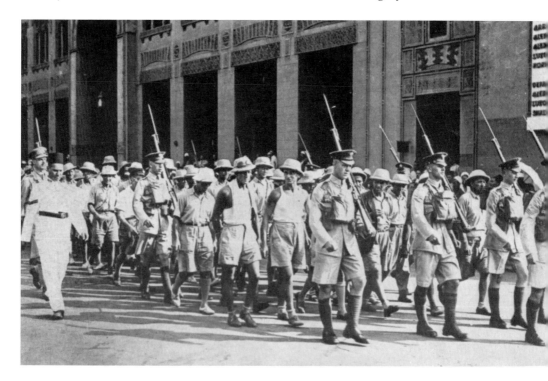

Above: Italian prisoners are marched into Cairo under armed escort. *Below:* A British armoured car crew find some unconventional but very welcome shade in Egypt.

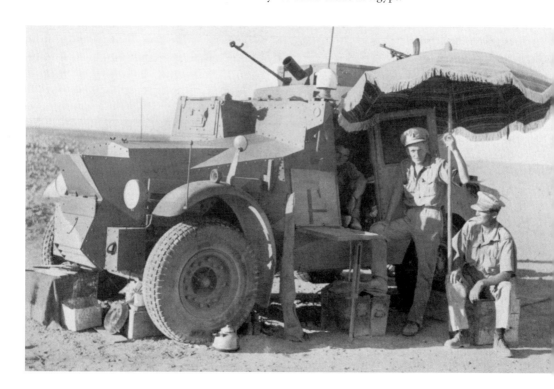

Armoured units in the desert. *Top:* Air Chief Marshall Air A. Langmore inspects a line-up of RAF armoured cars. *Lower image:* Some of the latest tanks which had arrived in Egypt.

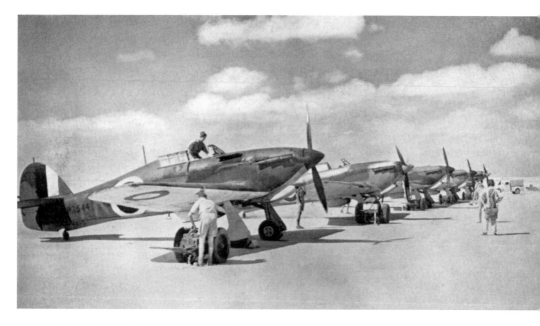

The build-up of Allied forces in North Africa included these Hurricanes, above, and Bristol Blenheims, shown below. The Hurricanes are preparing for a patrol of the Western Desert, looking for Italian forces.

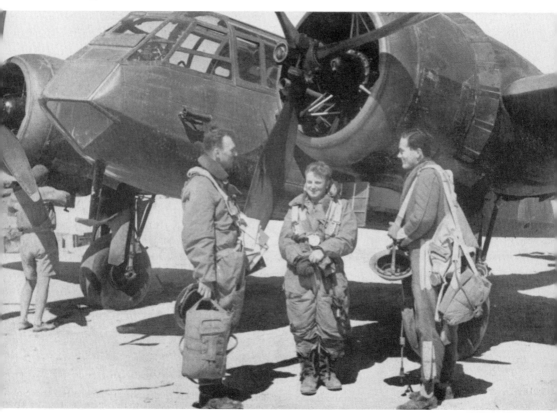

Above: A group of Frenchmen serving with the RAF in the Western Desert. While France was out of the war, many Frenchmen decided to continue the fight and were attached to Allied units. *Below*: Indian troops of a Bren-gun Carrier platoon in the desert.

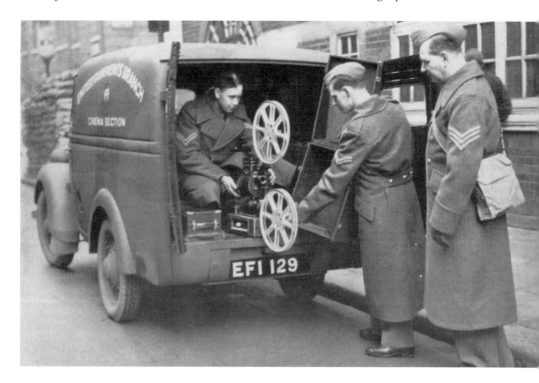

Entertainment for the troops. *Above:* This mobile unit toured the country, taking film shows to isolated camps. Boredom was always a serious problem for any army waiting for action. *Below:* Men and women in uniform play a game of billiards at the Brompton Dug-Out.

DECEMBER 1940

Above: An unexpected benefit of the war was an increase in the sale of British-made toys, such as these model aircraft being painted. Traditionally, Germany's toy industry had been the main supplier to the world's toyshops.

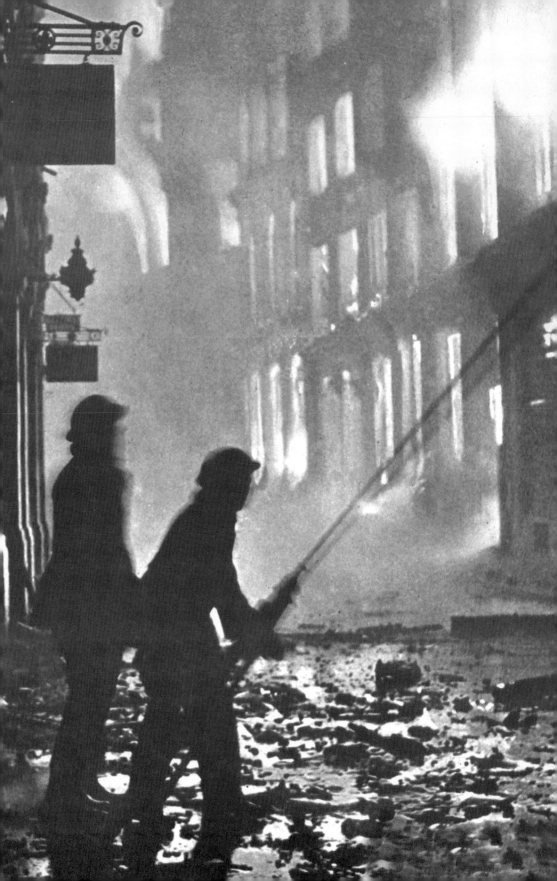

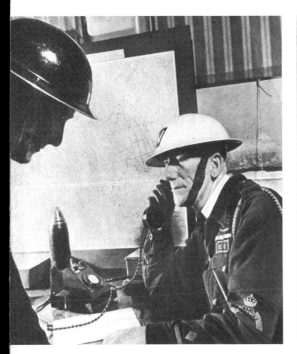

Opposite page: Fires rage in Ave Maria Lane in the East End. On 29 December 1940, the Germans attempted to set fire to the City of London by dropping around 10,000 fire bombs. *This page:* Men of the Rescue, Shoring & Demolition Squads (RSDs) set to work after an air raid to rescue victims of the bombing. These photographs were published in November 1940.

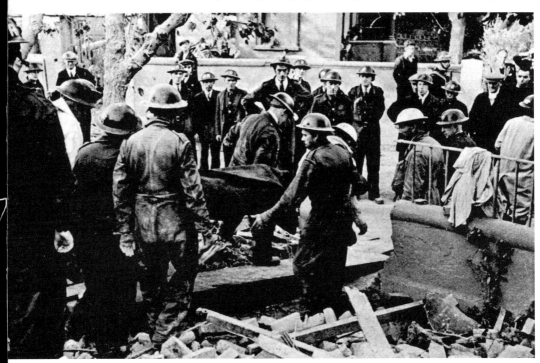

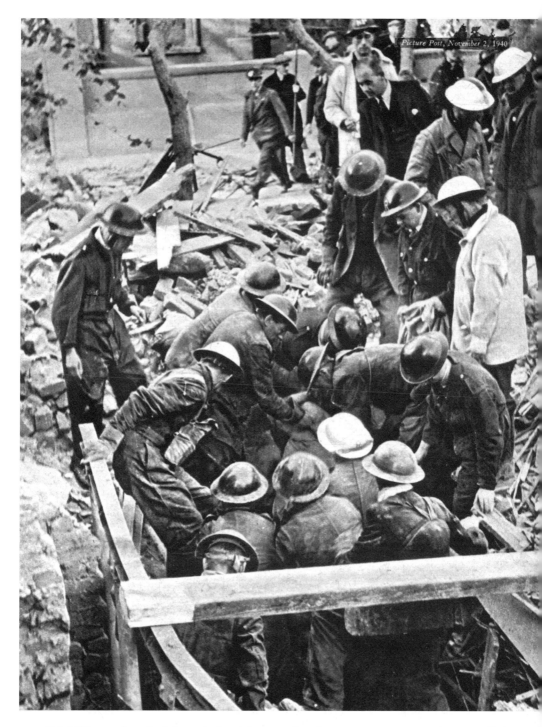

Picture Post, November 2, 1940

This RSD squad worked through the night, propping dangerous structures as they tunnelled to reach people trapped in the debris. It was difficult work, fraught with danger, but without them many victims would have suffocated or maybe drowned in the waters of a burst mains. The civilian members of the RSDs were enlisted by the county council.

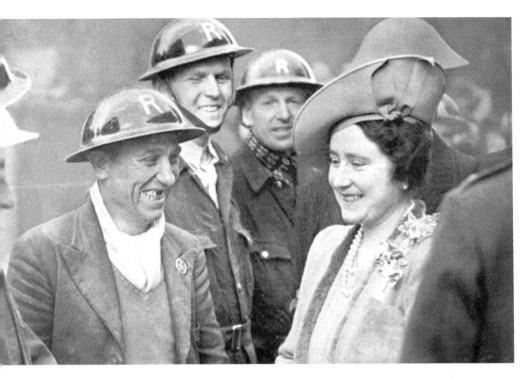

Above: The Queen meets members of one of London's RSD squads to congratulate them on their heroic work. *Below:* This photograph epitomises the British wartime spirit. It's business as usual whatever the Luftwaffe threw their way.

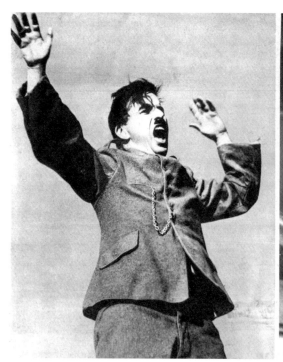
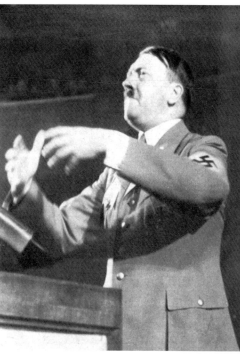

Charlie Chaplin's film portrayal of Hitler was spot on in terms of parody and propaganda, but although generally well received when it was released in late 1940, many commentators felt that *The Great Dictator* had come out a year too late.

Picture Post, November 2, 1

Born only four days apart in April 1889, Charlie Chaplin and Adolf Hitler also had obvious facial similarities. In the *The Great Dictator* Hitler is parodied by Chaplin as Adenoid Hynkel while Mussolini became Benzino Napaloni, and their love of uniforms and pageantry is played to the full. Compare the image on the opposite page with the one on the bottom of page 80.

The British film industry had turned to more gentle matters with a dramatisation of H. G. Wells' 1905 novel, *Kipps*. It starred Diana Wynard and Michael Redgrave, in the title role. They are shown above during filming in 1940, although the film was not released until June the following year. Note the steel helmets worn by the film crew.

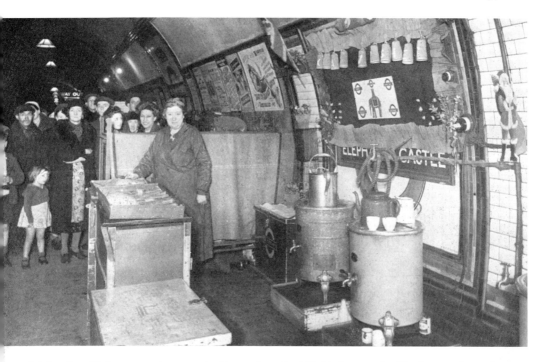

Celebrating Christmas underground. *Above:* A makeshift kitchen at the Elephant and Castle. *Below:* At Holborn station the kids are having a party complete with paper hats and carols with the mayor.

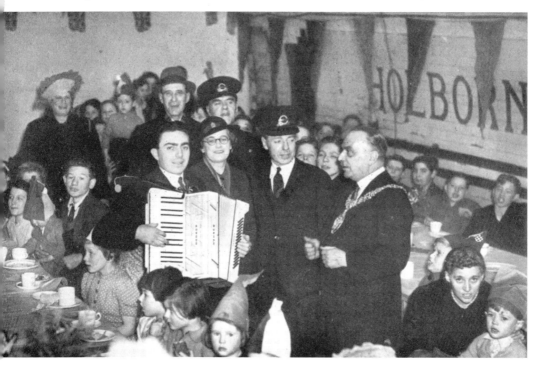

DO NOT GIVE ANYTHING TO THE PICTURE POST SPITFIRE FUND